On **February 13 2004**,
the government and Janjaweed attacked
the Al Hilf area, where they
destroyed all things in our village outside and in.
More than this, they killed
unarmed people, and took all the furniture
out of the houses to set fire.

They killed about 854 people in the area.
They also killed different animals.
They burned down the school and hospital,
and all medicine was taken.
They also set fire to our mosque.
Well water was destroyed by the Janjaweed and
government with fuel.

This caused much suffering in the village.
People of this area were suffering with disease, thirst, and hunger.
People had no roofs, leaving no
protection from the hot sun and coldness of the rains.

**Tell the
people
of America
and the
world
about the
countless
suffering
that happens
in Darfur.**

Al Halif villager, October 2004

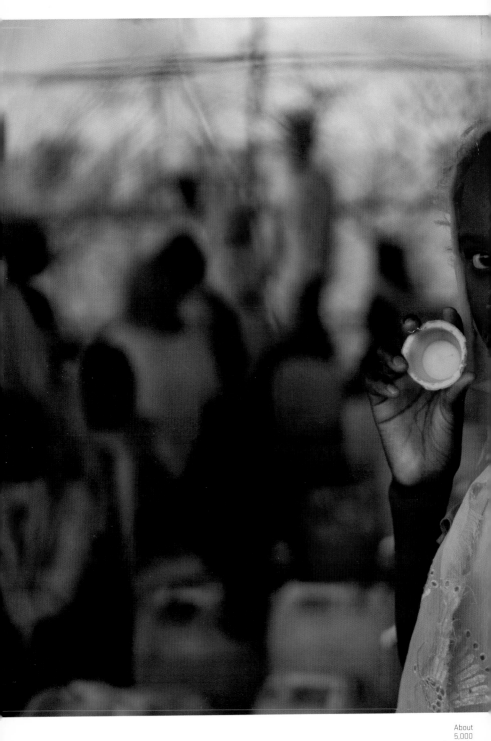

About 5,000 internally displaced persons (IDPs), including this young girl, have resided at the Derainge Camp for more than a year.

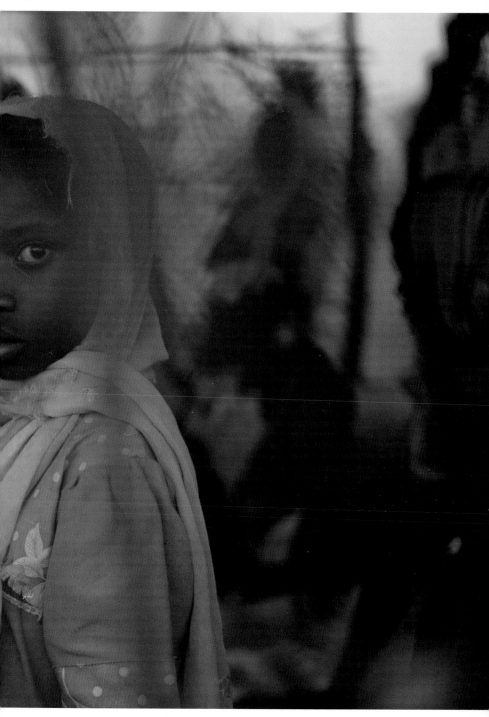

Ron Haviv : Outside Nyala, South Darfur, Sudan / June 2005

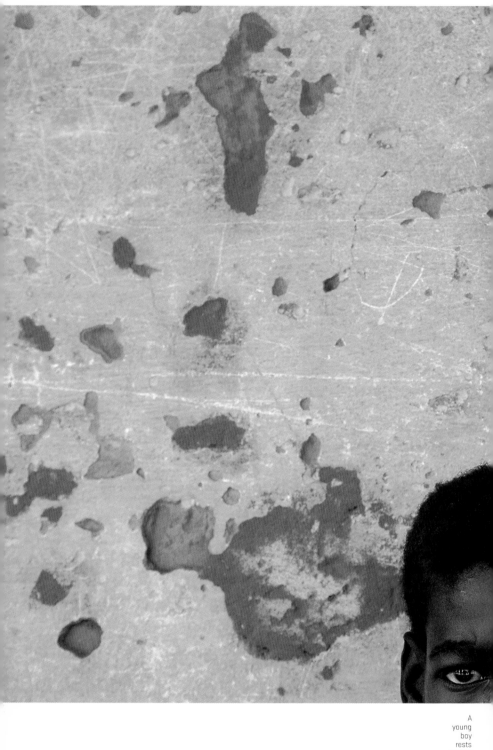

A
young
boy
rests
against
a
shrapnel-
scarred
wall
during
a
rebel
conference
for
the
Sudanese
Liberation
Army
(SLA).

Lynsey Addario : Haskanita, Darfur, Sudan / October 2005

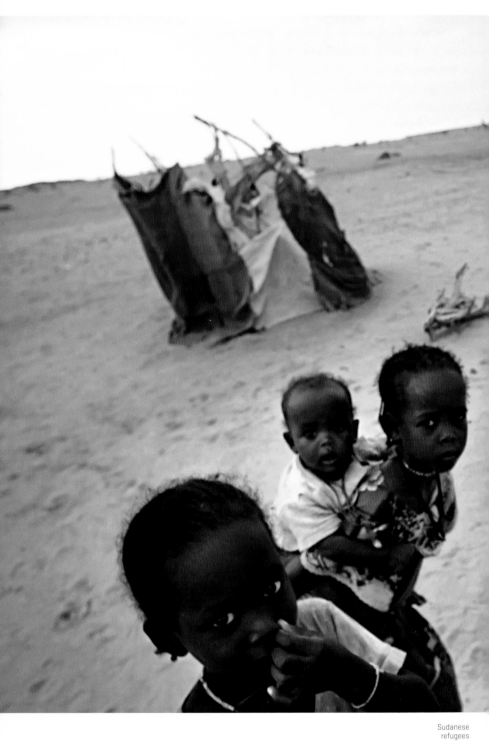

Sudanese
refugees
stand
at
dawn
by
a
tent
in
the
Oure
Cassoni
Camp,
about
seven
kilometers
from
the
Chad-Sudan
border.

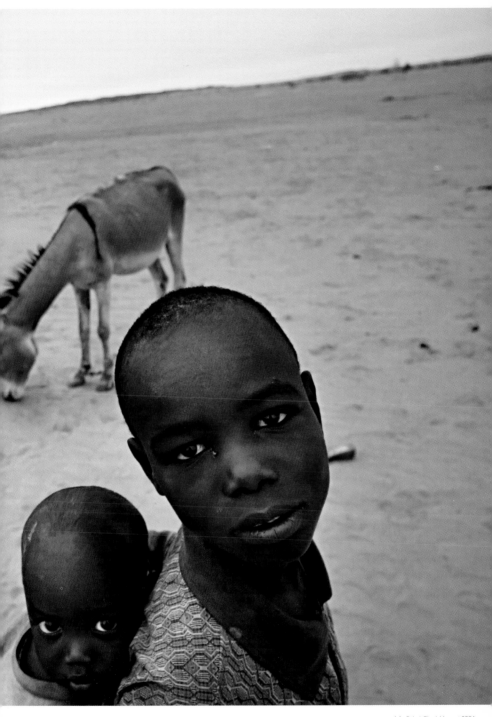

LA : Bahai, Chad / August 2004

After
surviving
attacks
by the
Janjaweed,
this
boy
now
resides
in Fina
where
the
population
has
tripled
as
people
from
surrounding
areas
have
flocked
there for
safety.

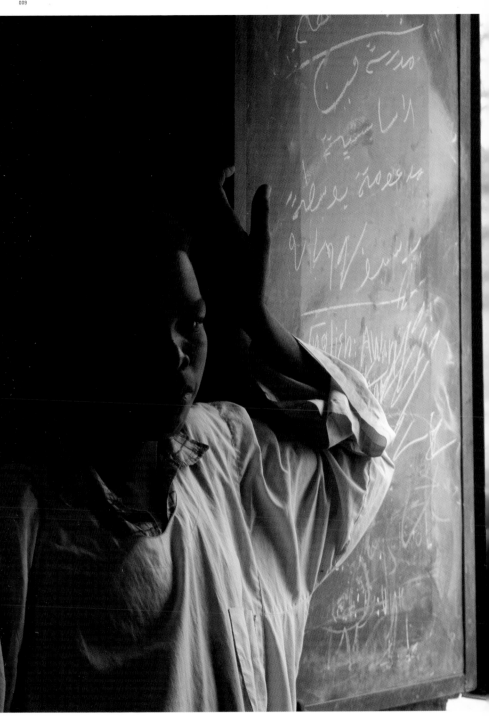

RH : Fina, North Darfur / June 2005

FOR MH AND NTH

DARFURDARFUR LIFE / WAR

Foreword by
Leslie
Thomas

Introduction by
Samantha
Power

Edited by
Leslie
Thomas

Photographs
by
Lynsey Addario
Mark Brecke
Hélène Caux
Ron Haviv
Paolo Pellegrin
Ryan Spencer Reed
Michal Ronnen Safdie
Brian Steidle

Published
by

MELCHER
MEDIA

in association with

and

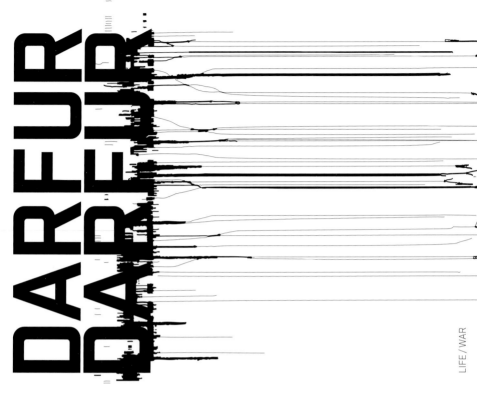

DARFUR

LIFE / WAR

TABLE OF CONTENTS

Foreword
by
Leslie
Thomas
016

Introduction
by
Samantha
Power
018

The
Photographs
022

Write
a
Letter
Save
A
Life
198

Glossary
202

About
the
Contributors
204

Acknoweldgments
207

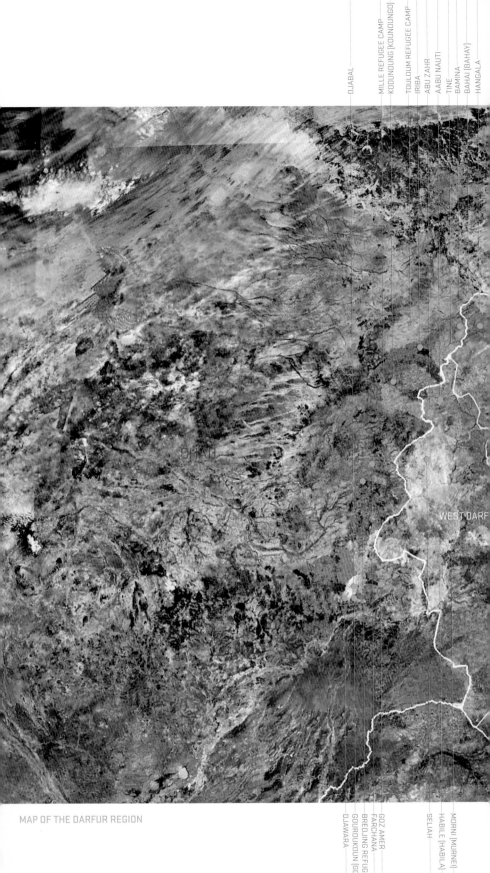

DJABAL

MILLE REFUGEE CAMP

KOUNOUNG (KOUNOUNGO)

TOULOUM REFUGEE CAMP

IRIBA

ABU ZAHR

AABU NAUTI

TINE

BAMINA

BAHAI (BAHAY)

HANGALA

DJEAU

WEST DARF

GOZ AMER

FARCHANA

BREDJING REFUGEE CAMP

GOUROUKOUN (GOZ-BEIDA)

DJAWARA

MORNI (MURNEI)

HABILE (HABILA)

SELIAH

MAP OF THE DARFUR REGION

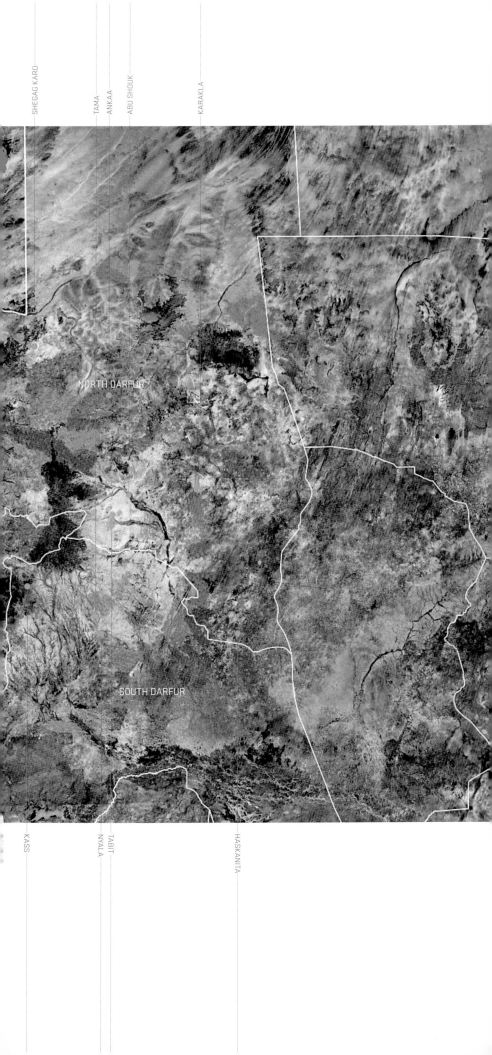

SHEGAG KARO

TAMA
ANKAA
ABU SHOUK

KARAKLA

NORTH DARFUR

SUDAN

SOUTH DARFUR

KASS

TABIT
NYALA

HASKANITA

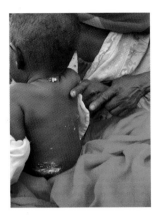

Mihad Hamid, whose photo is at the top of this page,
was my introduction to Darfur.
A beautiful one-year-old girl who sat bravely
while her lungs labored against the destruction of the
Janjaweed bullet
that had pierced her body hours before.

Brian Steidle took this picture
as evidence of a horrific war that has needlessly claimed too
many young lives.

This photo started a journey in which eight photographers
generously came together to tell the world a story
about the people of Darfur. Working with film editor J. Matthew
Jacob, and under the guidance and support of
Gretchen Steidle Wallace, the team wove together a narrative
about the celebratory life and tragic crisis that mark
western Sudan, eastern Chad, and northern Central African Republic.

A young boy rests his hand against a
window of a classroom—silhouetted in the dark,
waiting for a childhood he may never get.
Ron Haviv

A mother gathers her family
under the barest notion of a tree, everything she has
to feed her family adding up to
not more than a pot of water and a few scraps.
Michal Ronnen Safdie

Through the rain
a lone woman walks towards us as she battles the weather,
a traditional companion in Darfur,
but now one accompanied by gunfire and bombs.
Paolo Pellegrin

The face of a young soldier—
impossibly beautiful
and turned down,
his green turban silhouetted
against the sky—
waits with the patience and
resignation of long wars.
Lynsey Addario

The wariness in a young soldier's eyes
makes him older than he should be,
a mark of war and fear
coming to those too young to have to fight.
Mark Brecke

A baby is weighed at a refugee camp
and we see the real damage of war, not the collateral but the
center of it all.
Ryan Spencer Reed

A girl covers her mouth
with a beautiful piece of fabric,
the unimaginable story
that she must tell is muffled
by her battle with shame and fear.
Hélène Caux

And finally, a child—sitting in the lap of her sister,
her mother just dead and her own life
slipping through the bullet wound in her lungs—her beautiful body
desecrated by what we call war.

These images, woven together, tell the story
of the people of Darfur.

Acting as both a celebration of Darfur and
a narrative about a humanitarian disaster, this collection is meant
to shock and provoke you,
to allow you to fall in love with a child and
to make you stand up for her rights when they are trampled.

I have looked at Mihad's photo hundreds of times—still wishing,
still hoping, that I am wrong and that
she has somehow survived those brutal attackers
who committed this unspeakable horror.
But if she did not survive I want her to know that she has inspired us
and that her brief life will be remembered with joy and honor.

Mihad haunts
me and it is in her name
that this work is done.

Leslie Thomas

Any student of twentieth-century history
who looks at events in Darfur, Sudan, will see much that is familiar.
First, the province suffered
from decades of economic and political neglect
and discrimination. Then, in 2003, Darfurian rebels launched
an insurgency in an effort to win the area autonomy.
And, finally, the government decided to "drain the swamp" on the
insurgency, taking brutal systematic aim at civilians
and whole communities portrayed as
fifth columnists. The Sudanese authorities decided, in short,
to carry out genocide in Darfur.

The human toll of this violence may also seem familiar.
More than two million people from the Fur, Zaghawa, and Massalit
(non-Arab) tribes have been displaced. They are being
kept alive by international life support that could be
terminated at any moment.
As many as 400,000 people have been killed—an imprecise
number because independent verification is blocked, but a
number that is most certainly rising by the day.
And rape has become a preferred tool of destruction.
In a pattern that does not deviate by geography and thus cannot
have been simply a spontaneous by-product of "war,"
Arab militia and government soldiers
have regularly assaulted non-Arab women, doing so not only to
"create lighter skinned babies," as the marauders taunt,
but also to take aim at the most precious commodity
a traditional community has—a commodity far more prized than
land and livestock—its dignity.

After World War II,
the major powers agreed to ban what were described
as "crimes that shocked the conscience."
But as we entered the twenty-first century, it was fair to ask,
given all we know about the Holocaust,
the Khmer Rouge,
Saddam Hussein's genocidal warfare against
the Kurds, Bosnia, and Rwanda, could anything,
in fact, still shock the conscience?

The Sudanese government and its proxy Arab militia
have cleansed, raped, and killed in
Darfur on the assumption that they could do so with impunity.
They reached this conclusion for several reasons.
First, they, too, were students of history.
They knew that powerful governments generally do little when
Africans are being butchered. The closest a western government
has come to affirming African life in the face of genocide
was President Clinton's statement of regret four years after his
administration demanded the withdrawal of UN peacekeepers
from Rwanda during the 1994 genocide. "It may seem strange to
you here," Clinton told Rwandans,
"especially the many of you who lost members of your family,
but all over the world there were people like me sitting in offices,
day after day after day, who did not fully appreciate

the depth and the speed with which you were being engulfed
by this unimaginable terror."
If this was the most robust affirmation of African life
that a western leader would muster—and it must be noted,
the statement of regret meant the world to Rwandans—
then Khartoum could safely assume that they would face minimal
interference as they went about their business.

The second factor behind
Sudan's sense of invulnerability was the so-called "war on terror."
In the wake of 9/11, the Bush administration
stepped up counterterrorism cooperation and intelligence-sharing
with Sudan, where bin Laden had resided in the 1990s.
Moreover, Washington's cataclysmic invasion of Iraq,
its failure to observe basic tenets of international law,
and its overall diminished standing in the world
meant that when the Bush administration denounced
Khartoum's atrocities and
called on other major powers to join it in pressuring the regime,
global audiences were suspicious.
They were unconvinced by an administration that
urged action on Darfur one day and endorsed "water-boarding" as
a legitimate tool of statecraft the next.

And the third factor Sudan banked on,
in wiping out civilian villages, was the rise of new powers.
Russia, an ascendant petro-authoritarian power,
has begun threatening to use its veto on the
UN Security Council to dilute or thwart UN-led resolutions aimed
at upholding human rights and promoting international security.
And by far the most important friend Sudan has on
the Council is China, which imports about two-thirds of the oil
Sudan produces and leads all outside powers in foreign direct
investment in the country.
Beijing has benefited more than any other country from the
violent status quo. Because of Sudan's atrocities,
the U.S. Congress has imposed economic sanctions,
prohibiting U.S. companies from doing business in the country.
This has given Chinese companies (as well as other
multinational businesses) free reign to set up shop,
without any U.S. competition.

So given all of these grave structural forces working against
rescue, do the people of Darfur even stand a chance?
Shockingly, they do.
And they stand a chance because of the one wholly novel,
unfamiliar aspect of the Darfur tragedy: the bottom-up domestic
anti-genocide movement that has gathered
force in the United States.
Starting in 2004, around the ten-year anniversary of the outbreak
of the Rwandan genocide,
a number of forces converged to create a political constituency
that has forced Washington to take notice. The movement
got much of early oxygen from Nick Kristof, who as of
September, 2007, had written almost eighty columns on Darfur.

Samantha Power

And it was fed by the activism of an array of groups that decided
that this time around, they would not stand idly by:
students who had seen Holocaust documentaries,
Steven Spielberg's **Schindler's List,** or
Terry George's **Hotel Rwanda,** or those who had read
Philip Gourevitch's **We Wish to Inform You that Tomorrow We
Will be Killed with Our Families;**
evangelical groups that had been shocked by the testimony of
missionaries who had worked in southern Sudan;
and Jewish groups that built on the advocacy they had
done a decade before in response to the Serb slaughter of Bosnians,
and who reasoned that "genocide"—and in September 2004
Secretary of State Colin Powell issued a formal legal
finding of genocide—demanded individual and collective action.

The results of this political and social action
have been decidedly mixed.
The good news—on an otherwise grim landscape—is that
the pressure has forced the Bush administration to go
along with a United Nations resolution to refer the crimes carried
out in Darfur to the International Criminal Court, which
has issued arrest warrants for two suspects.
Notwithstanding the U.S. mounting financial deficit,
the pressure has meant that the U.S. Congress was forced to carry
the lion's share of the burden of keeping the refugee and
displaced persons camps afloat.
Washington spent some $2 billion on aid to Darfur.
Citizen advocates have pushed the Bush administration to insist
on the deployment of a UN protection force
with a robust mandate, and, despite the ambivalence of Russia
and China, and the objections of the Sudanese government,
this effort resulted in a Security Council resolution authorizing the
deployment of a 26,000-person peacekeeping force in July 2007.
And although the political negotiations
between Khartoum and Darfurian rebels have long stalled,
U.S.-based activists understand that protection forces will only
offer stop-gap succor until a durable,
enforceable peace settlement is reached.
The State Department will eventually have no choice but to
reinvest itself in that political process.

One of the most remarkable aspects
of the anti-genocide movement is how adaptable it has proven.
Recognizing that the Bush administration was not itself able
to influence events,
in 2005 advocacy groups bypassed the U.S. government and
began to pressure China directly.
Students and other activists launched a divestment campaign,
at last count convincing fifty-five universities and twenty states to
adopt divestment policies regarding Sudan.
Chinese companies have felt the heat, as have mutual fund
portfolios holding stocks of companies like the Sinopec,
the Chinese oil giant.
The activists have also pushed ahead with the
"Olympic Dream for Darfur" campaign, urging China to use its

influence to stabilize Darfur in advance of what should be a
groundbreaking 2008 Olympics.

Of course, for all of these hopeful signs,
the bad news
from Darfur greatly outweighs the good.
China's engagement has been spasmodic and unfeeling.
Beijing still seems unmoved either by the human stakes
of the violence or by the financial and reputational costs of
allowing atrocities.
The country's reverence for sovereignty,
which insulates it from criticism of its own human rights record,
thus far outweighs its interest in promoting stability.
Europe, which one might have expected to join the
United States in denouncing the atrocities and energetically
working to find a solution,
has been half-hearted in its engagement.
Sadly, the Darfur movement that has put Darfur on the map
in Washington—and, to a lesser extent, Canada—has not
gained meaningful traction in other western capitals.
And while several African countries have bravely stepped up
to send monitors and protection forces to Darfur,
many African leaders seem more interested in resisting
American influence than they do in saving lives.

Because U.S. citizens have learned
one important lesson from the twentieth century—governments
will not act to stop genocide unless
they are pressed to act—Darfur is not an orphan.
But the one parent the province has—the United States—is seen
to be radioactive internationally,
and too many other countries have their own
strategic and domestic political reasons for doing nothing,
or even for supporting Khartoum.

All of this is abstract political analysis.
It is an account of why the first genocide of the twenty-first century
has been allowed to persist.
But when one looks through the following pages,
studying the anguished faces of proud Africans who have watched
their loved ones murdered and
then have been forced to live in squalor,
stripped of that dignity they cherish,
one is overwhelmed with rage, with sorrow, and with shame. These
chilling and humbling photographs transport us to Darfur, a place
where any "explanation" of international dynamics
fails to suffice.
All of us—citizens, journalists, aid workers, bureaucrats,
and politicians—must open ourselves up and allow these
photographers to restore our sight and, again,
all these years after the Holocaust, to shock the conscience.

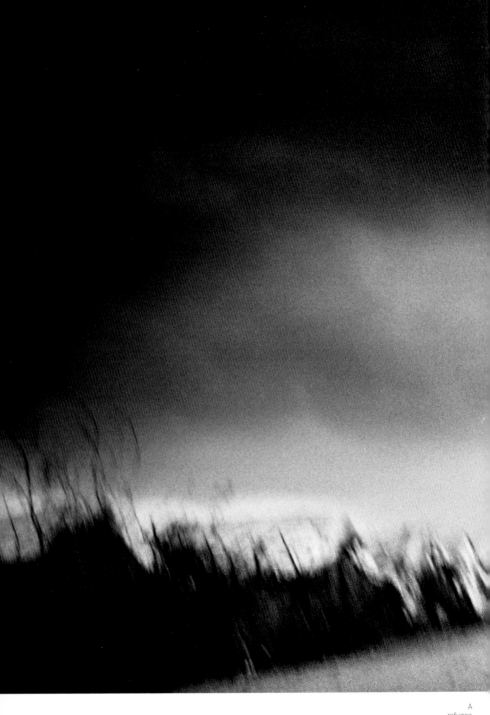

A
refugee
walks
through
a
rainstorm
at
a
camp
in
the
Kass
region.

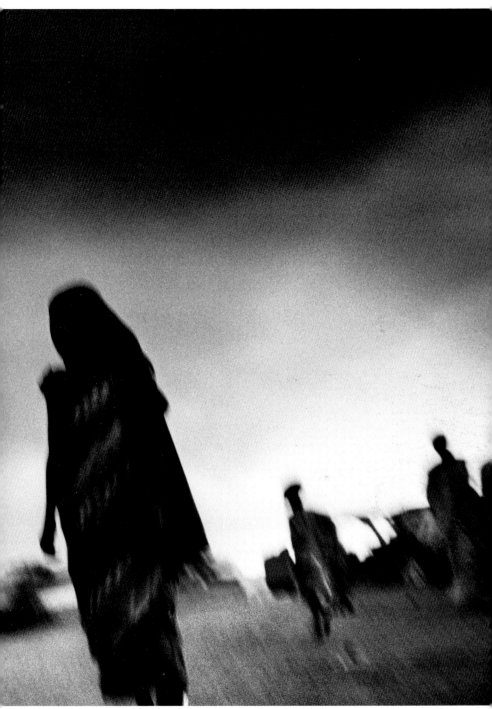

Paolo Pellegrin : Darfur, Sudan / Summer 2004

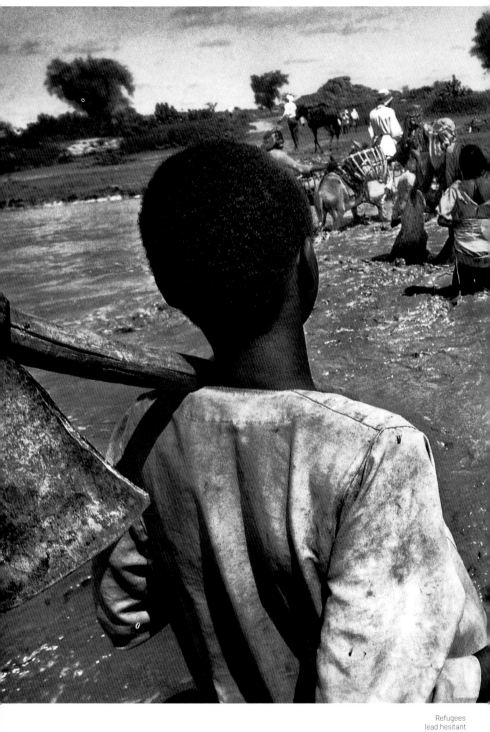

Refugees
lead hesitant
animals
through swollen
riverbeds
during the
rainy season
in eastern
Chad.
The wadis, or
"seasonal rivers,"
course
through the
landscape
at the rush
of the
first rains.
Many routes
are rendered
impassable,
which
drastically
impedes
relief efforts.

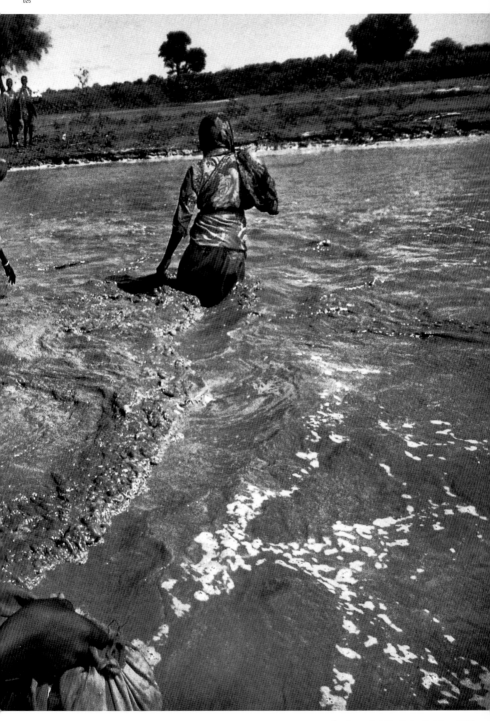

Ryan Spencer Reed : River, Eastern Chad / August 2004

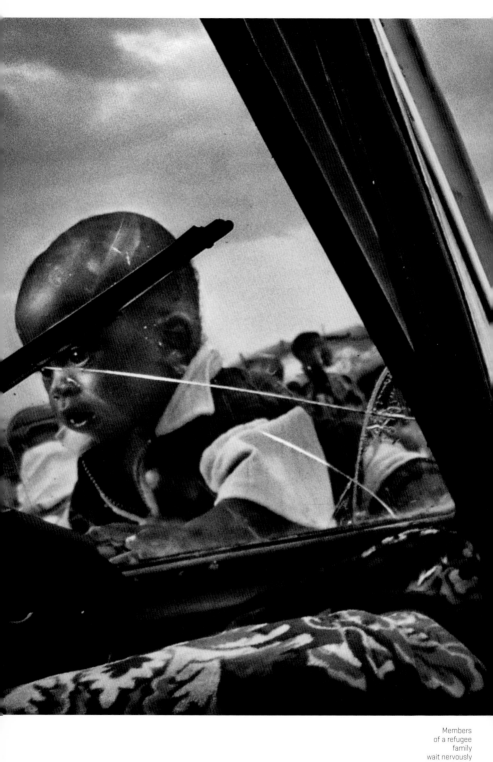

Members
of a refugee
family
wait nervously
before
being separated
from
each other.
The father is
sending his
children and
wife to get
medical
treatment
in a town
over 500
kilometers
away.
He must remain
in the border
town of
Tine where
he has started
a business.

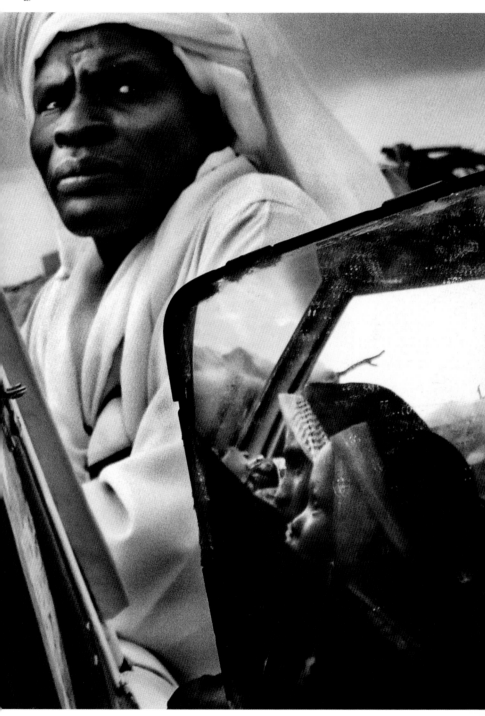

RSR : Market in Tine, Eastern Chad / August 2004

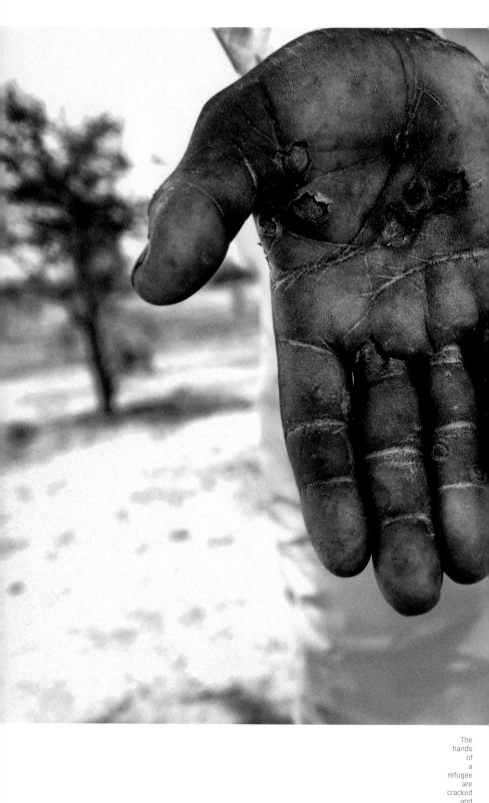

The hands of a refugee are cracked and blistered by a mysterious affliction.

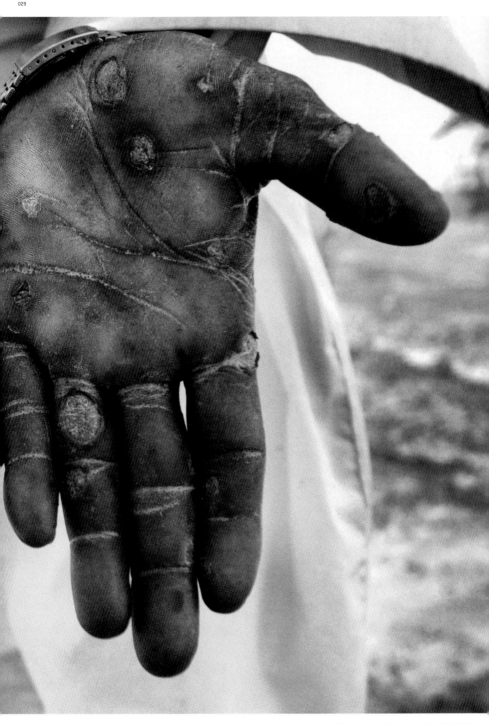

RSR : Mille Refugee Camp, Eastern Chad / July 2004

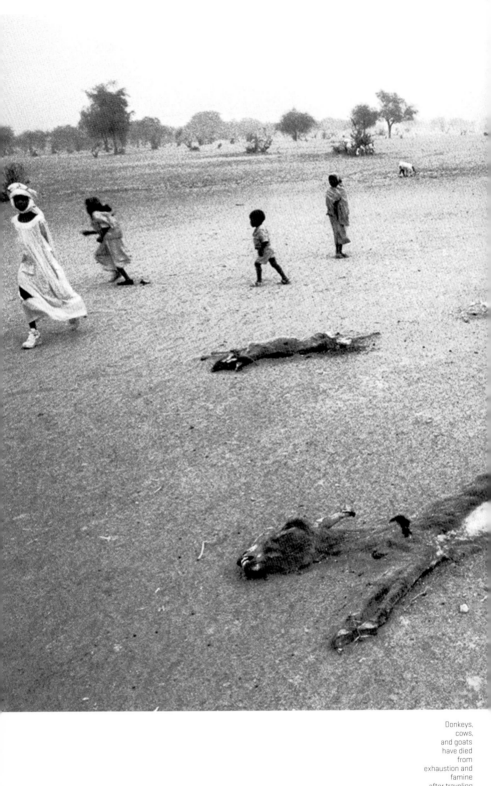

Donkeys,
cows,
and goats
have died
from
exhaustion and
famine
after traveling
from Darfur
to Chad
with fleeing
refugees.
The
death of these
animals
is a
catastrophe
for the
refugees,
most of
whose herds
have been
stolen by
the Janjaweed.

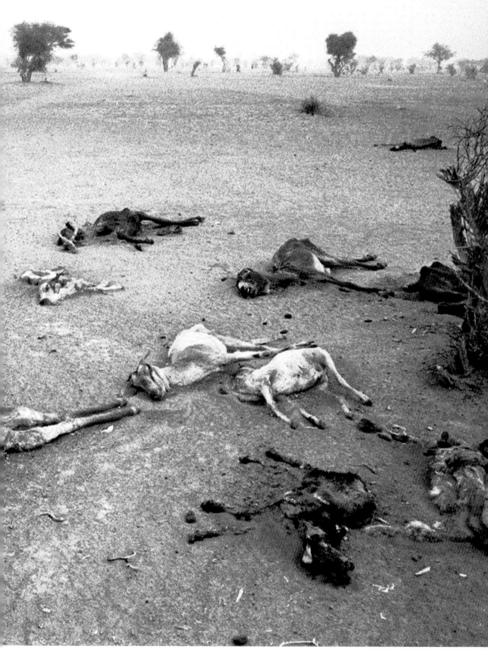

Hélène Caux : Bahai, Eastern Chad / March 2004

A young boy braves a sandstorm, which will last several days, as his family reaches Chad after escaping from the Janjaweed.

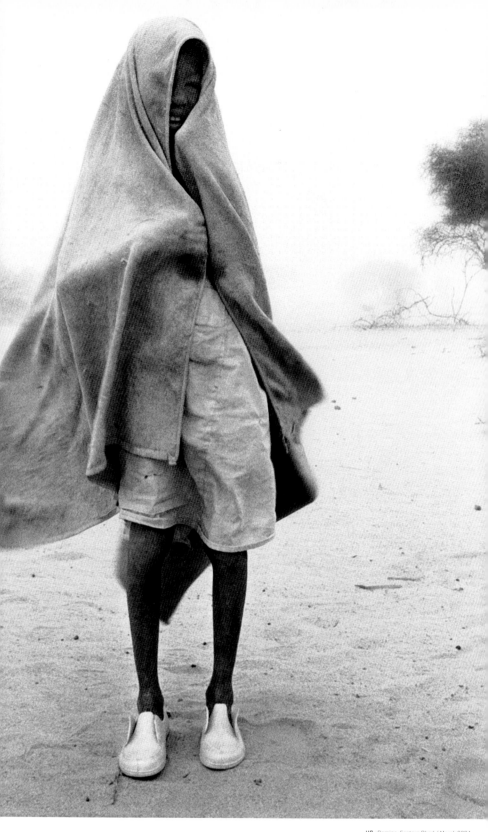

HC : Bamina. Eastern Chad / March 2004

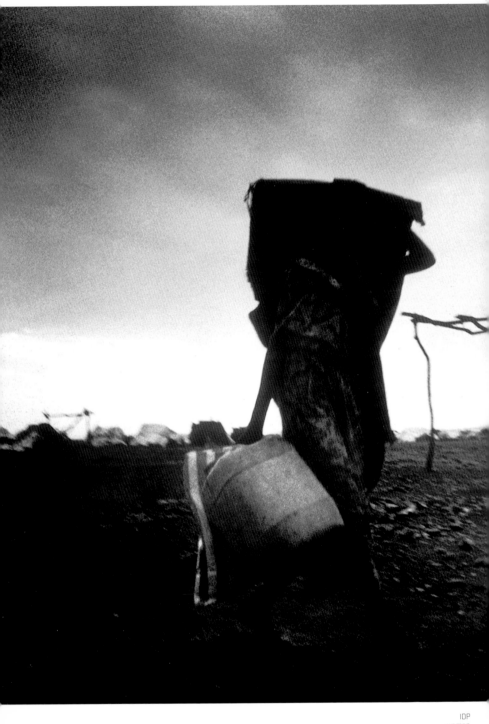

IDP
women
carry
charcoal
in
the
Kass
Camp.

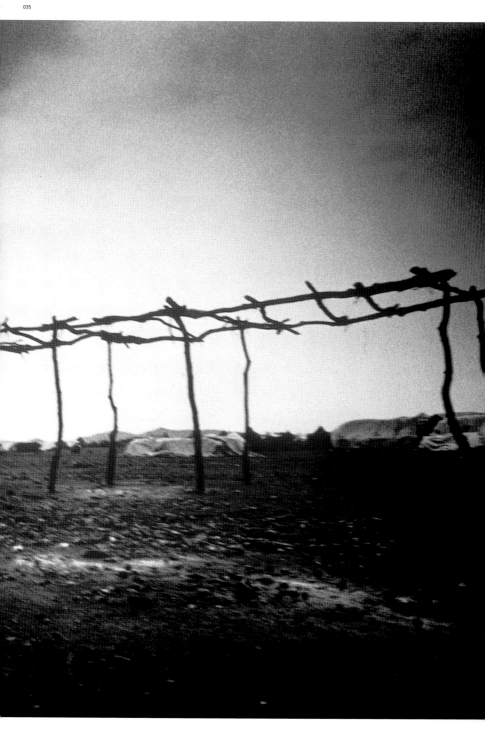

PP : Darfur, Sudan / Summer 2004

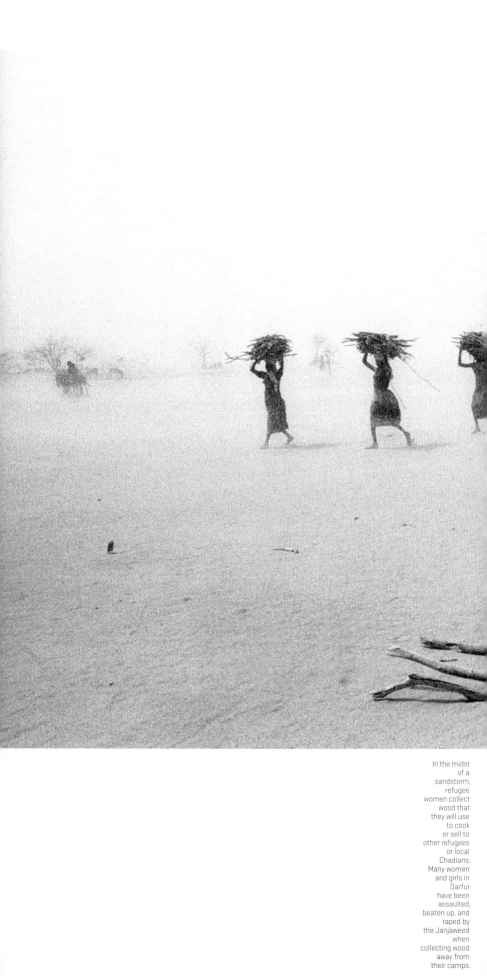

In the midst of a sandstorm, refugee women collect wood that they will use to cook or sell to other refugees or local Chadians. Many women and girls in Darfur have been assaulted, beaten up, and raped by the Janjaweed when collecting wood away from their camps.

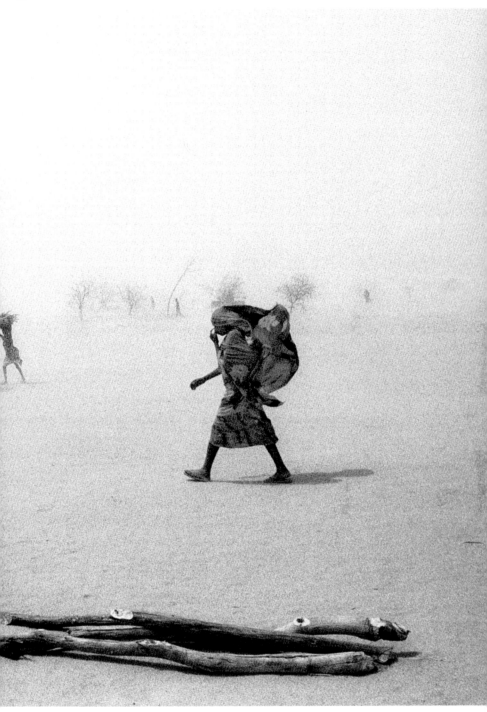

HC: Near Iriba, Eastern Chad / June 2004

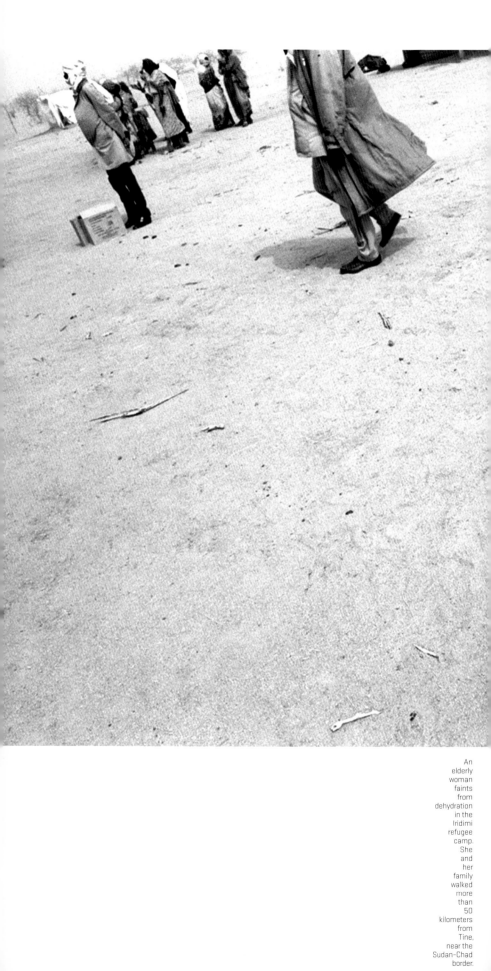

An elderly woman faints from dehydration in the Iridimi refugee camp. She and her family walked more than 50 kilometers from Tine, near the Sudan-Chad border.

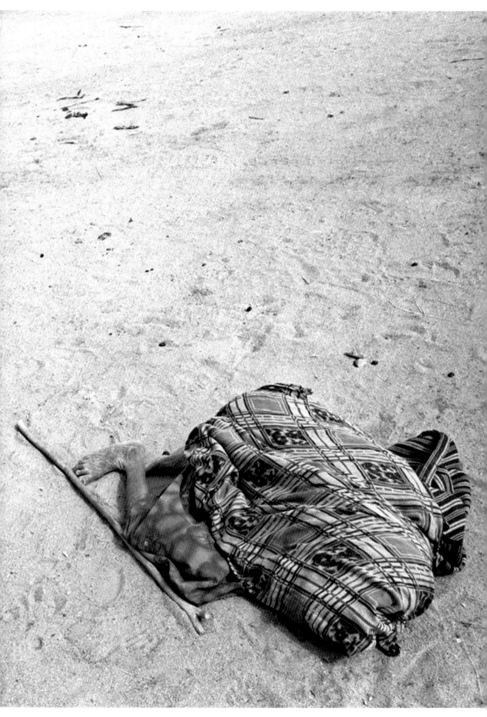

HC : Near Iriba, Eastern Chad / March 2004

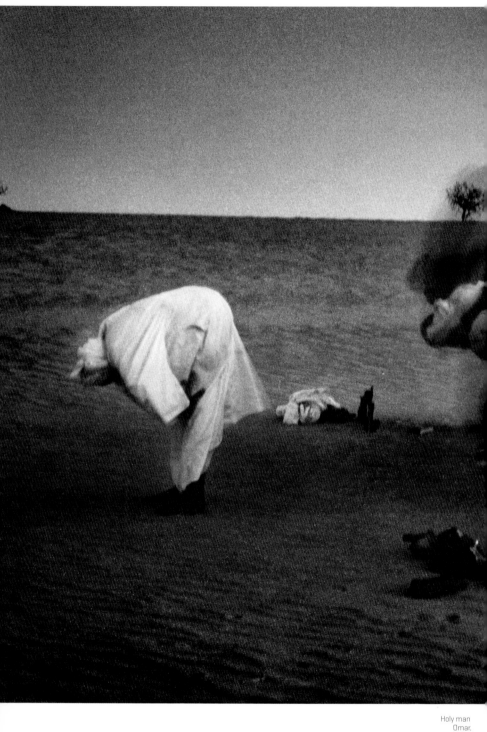

Holy man
Omar,
of the
Justice
Equality
Movement
(JEM),
leads a
group of
rebel
soldiers
in evening
prayers.

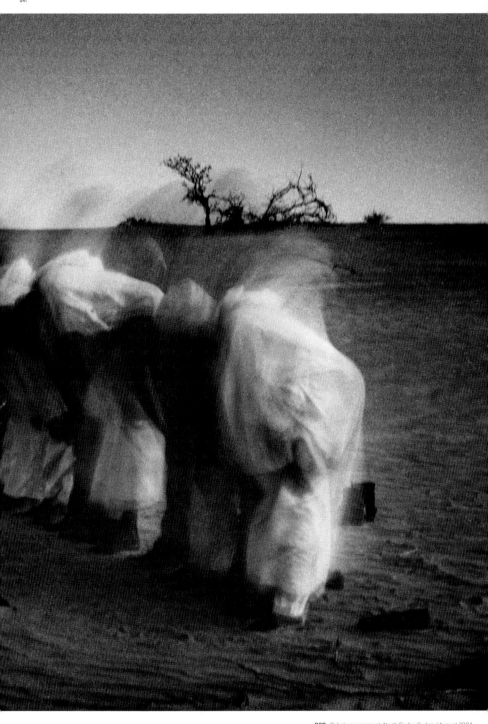

RSR : Rebel encampment, North Darfur, Sudan / August 2004

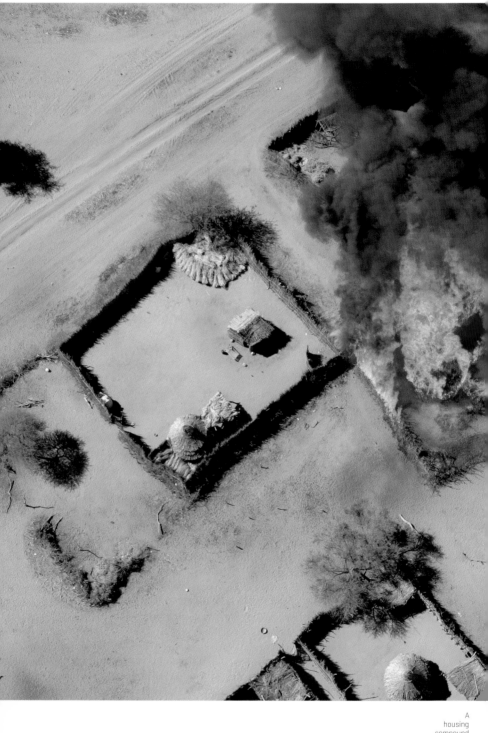

A
housing
compound
burns
after
an
attack
by the
Janjaweed.

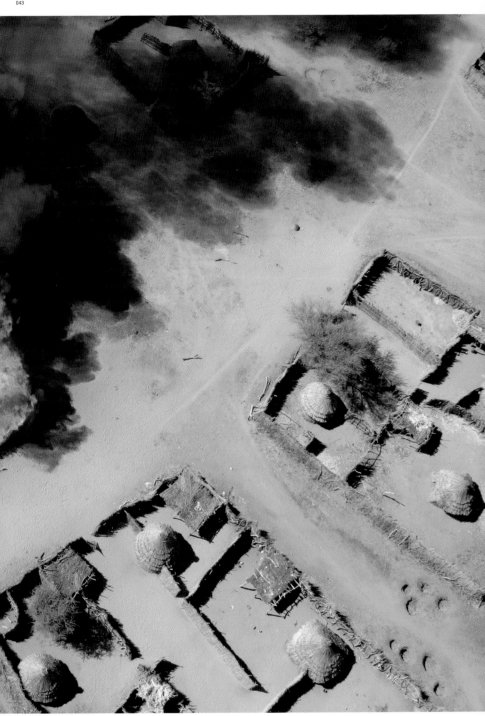

CAPTIONS FOR FOLLOWING PAGES

Brian Steidle : Um Ziefa, South Darfur / December 2004

LEFT TOP AND MIDDLE
BS : Um Ziefa, South Darfur / December 2004
A view of a burning village that has been devastated by fire.

BOTTOM LEFT AND TOP RIGHT
BS : Alliet, Darfur / October 2004
A view of another village that has been destroyed by fire.

RIGHT MIDDLE AND BOTTOM
BS : North of Jayjay / January 2005
Fifteen animals were stolen from the Janjaweed. As punishment, the
Janjaweed burned 15 villages. This is one of those villages.
HC : Amaratah, West Darfur, Sudan / December 2004
Thirty-five families lived in this village prior to the war. The burning is
seen as a systematic attempt to prevent IDPs from returning to their
native villages.

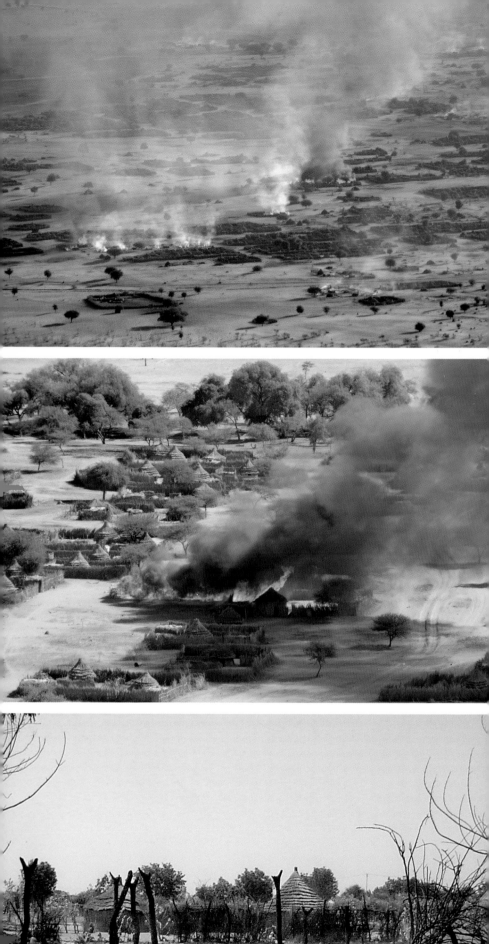
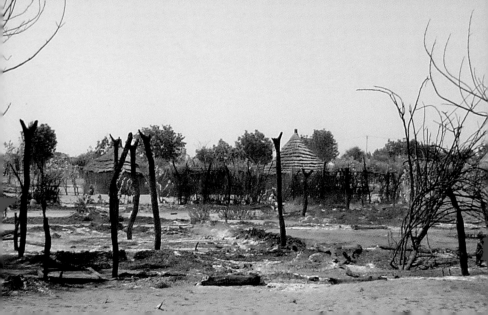

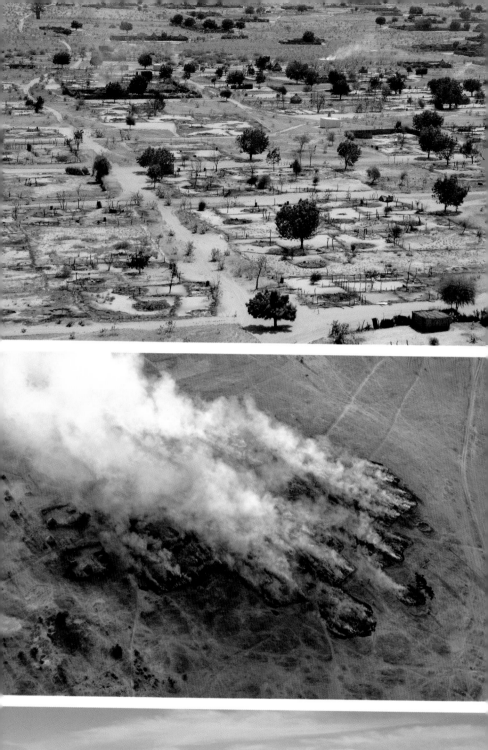

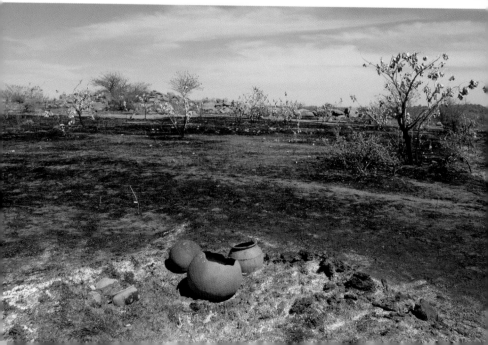

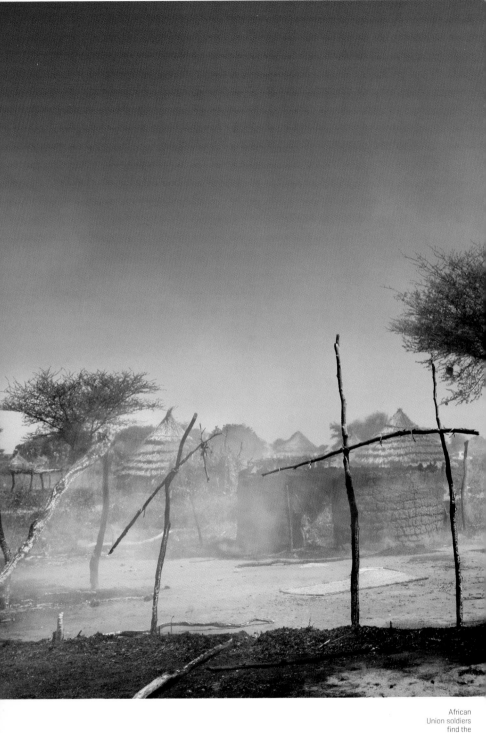

African Union soldiers find the village of Tama freshly burning more than a week after it was attacked by Arab nomads backed by government forces north of Nyala.

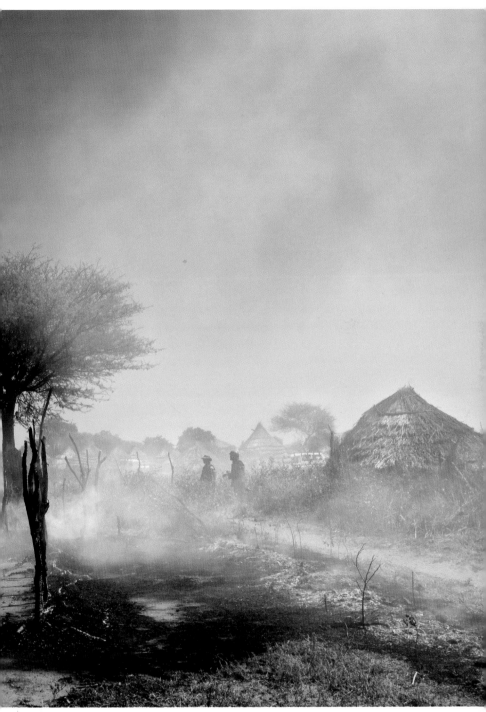

LA : Tama, Darfur, Sudan / November 2005

Fatima Tom Adam, age 35, says the Janjaweed killed her first husband and shot her in the face two years ago. The bullet entered under her eye and exited from behind her ear. She left her village of Abunduruk in Sudan and now waits with her children in the Farchana camp in Chad.

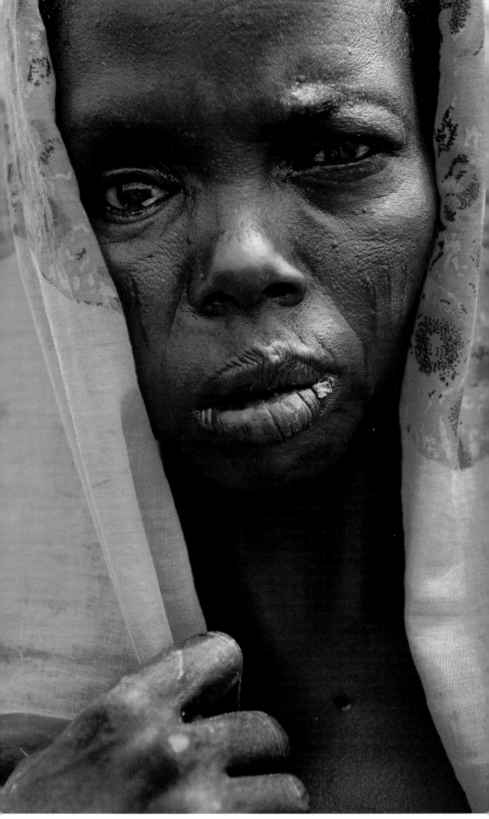

LA : Farchana. Chad / August 2004

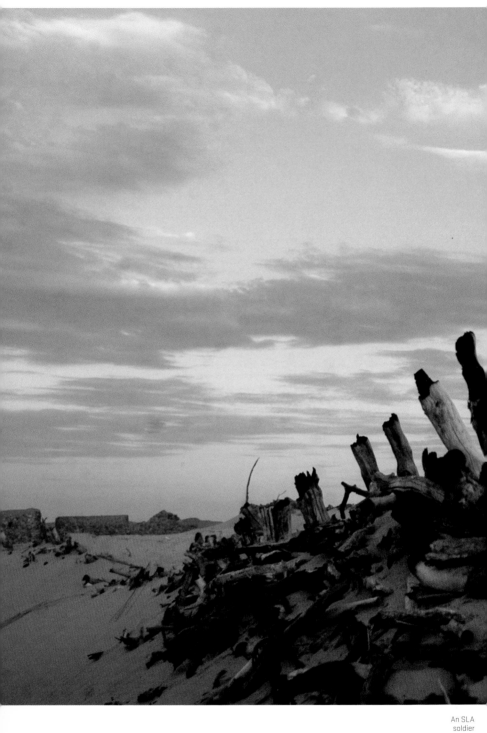

An SLA
soldier
surveys
the
remains
of
Hangala,
which
was
burned
by
the
Janjaweed.

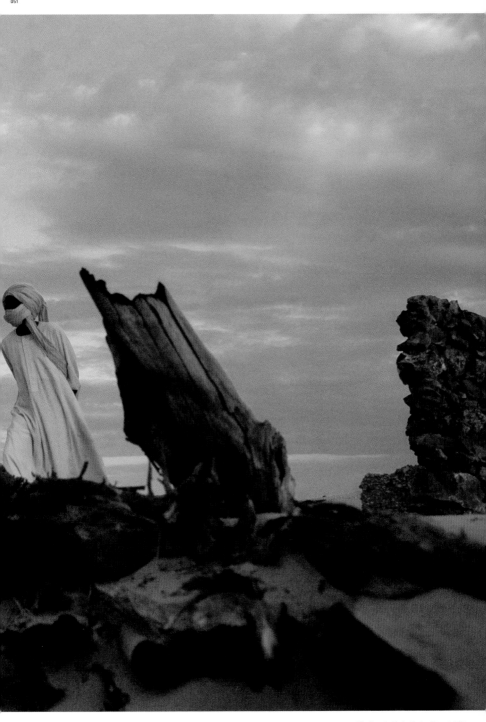

LA : Hangala, Darfur, Sudan / August 2004

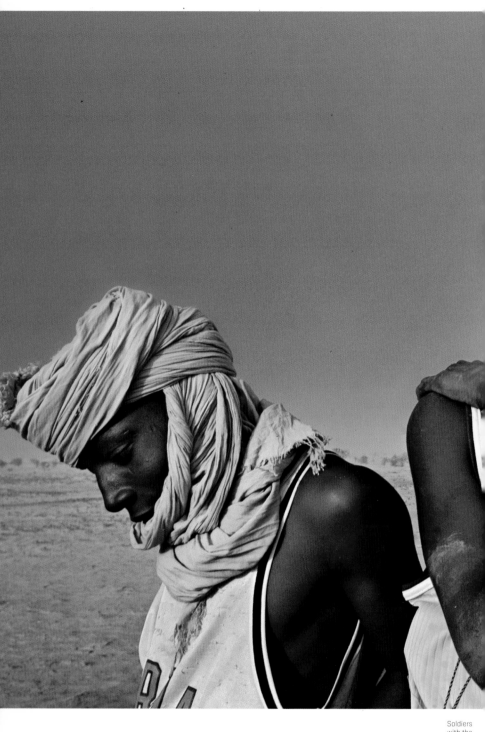

Soldiers with the SLA wait by their truck, while stuck in the mud. The rebels staged a 24-hour boycott against the Nigerian peace talks for Sudan after a new crop of civilian attacks, which killed 75 people from six villages.

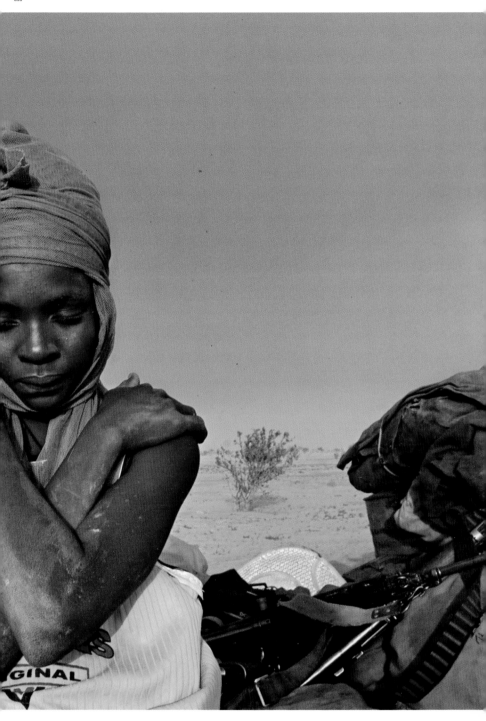

LA : Darfur, Sudan / August 2004

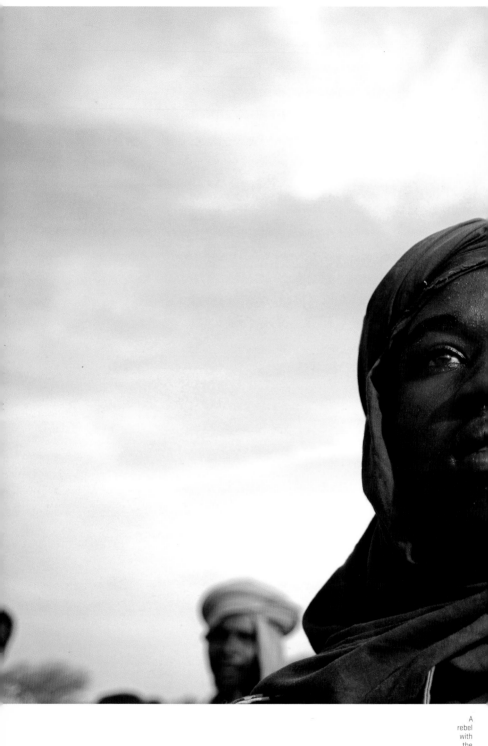

A
rebel
with
the
SLA
prepares
to
train
at
dawn
during
a
rebel
conference.

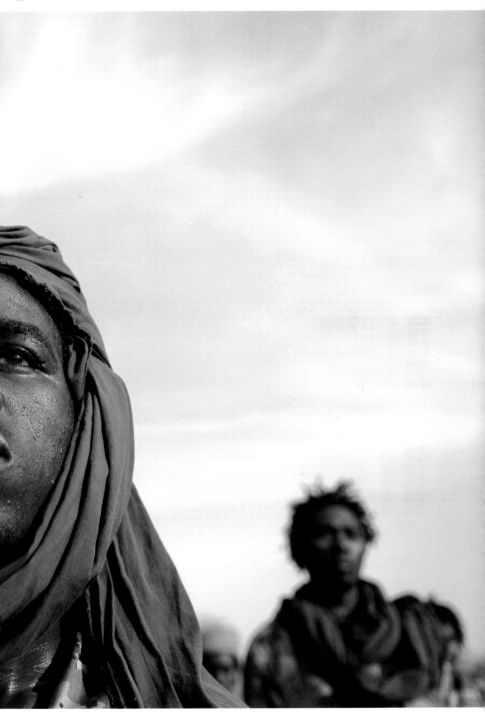

LA : Haskanita, Darfur, Sudan / October 2005

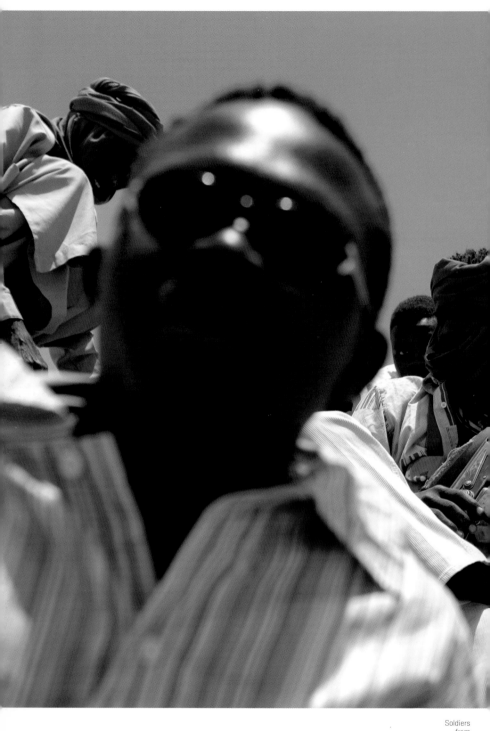

Soldiers
from
the
SLA
patrol
their
territory
just
a
few
kilometers
from
government
lines.

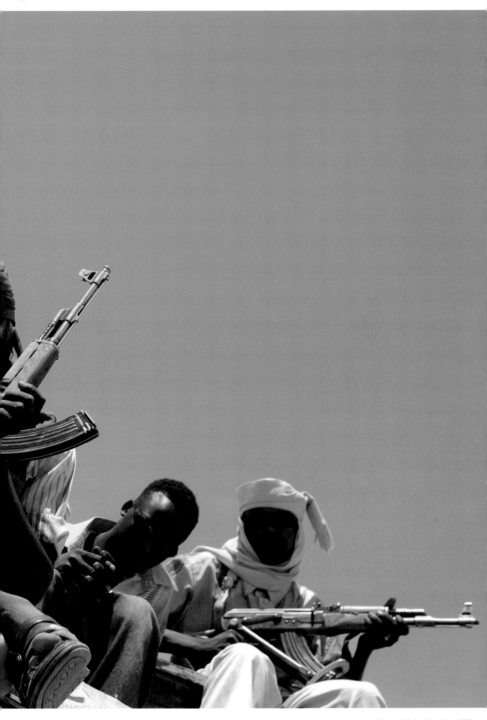

RH : North Darfur, Sudan / June 2005

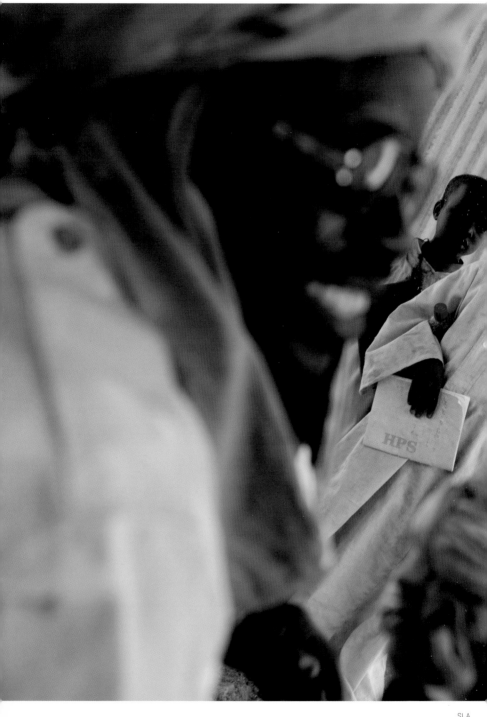

SLA soldiers blend in with daily life in Tabit, which houses more than 13,000 people.

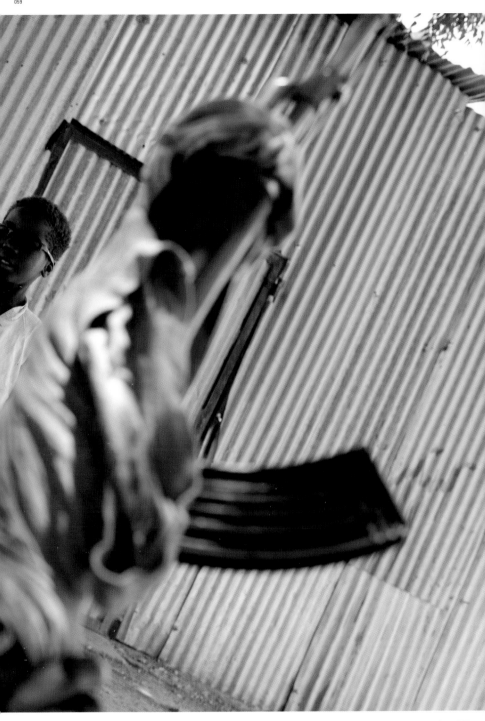

CAPTIONS FOR FOLLOWING PAGES

LEFT TOP TO BOTTOM
LA : Shigekaro, Darfur, Sudan / August 2004
SLA soldiers man the village during a sandstorm
LA : Haskanita, Darfur, Sudan / October 2005
Rebels with the SLA train at dawn during a conference.
LA : Shigekaro, Darfur, Sudan / August 2004
Thirteen-year-old Khalid Saleh Banat, a soldier with the SLA, stands
with his comrades after training.

RIGHT TOP TO BOTTOM
LA : Shigekaro, Darfur, Sudan / August 2004
Soldiers with the SLA at dawn.
RH : North Darfur, Sudan / June 2005
SLA rebels enjoy a game of cards.
HC : Eastern Chad / May 2004
Chadian gendarmes stand watch in the Oure Cassoni camp in the
northern region of Eastern Chad.

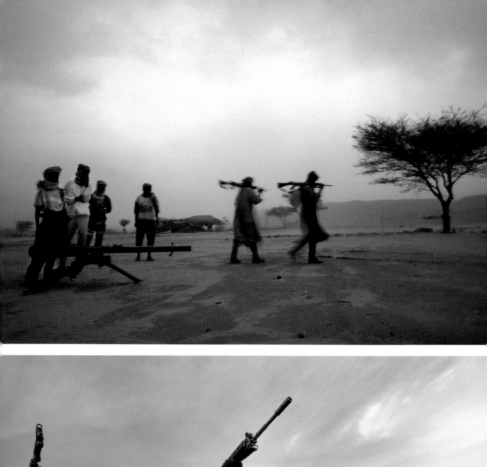

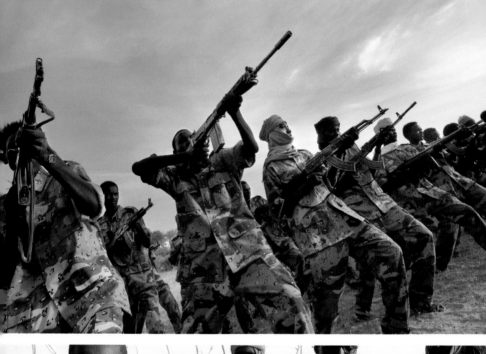

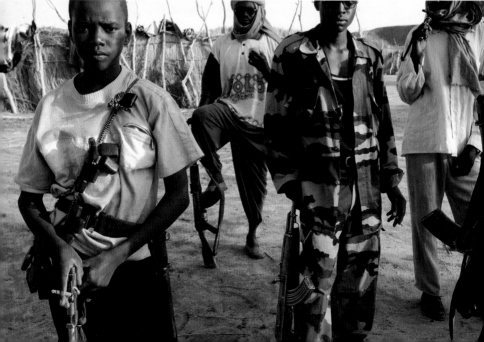

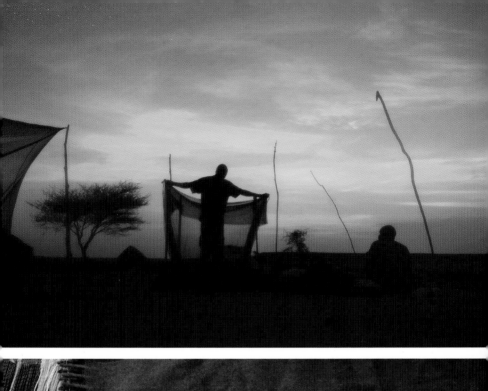

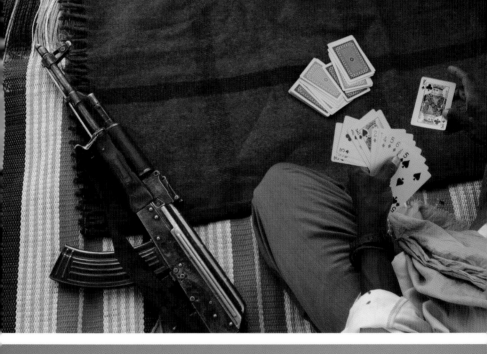

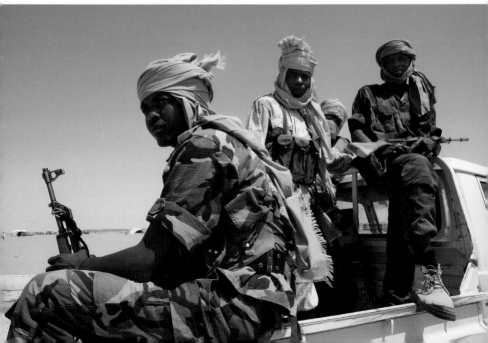

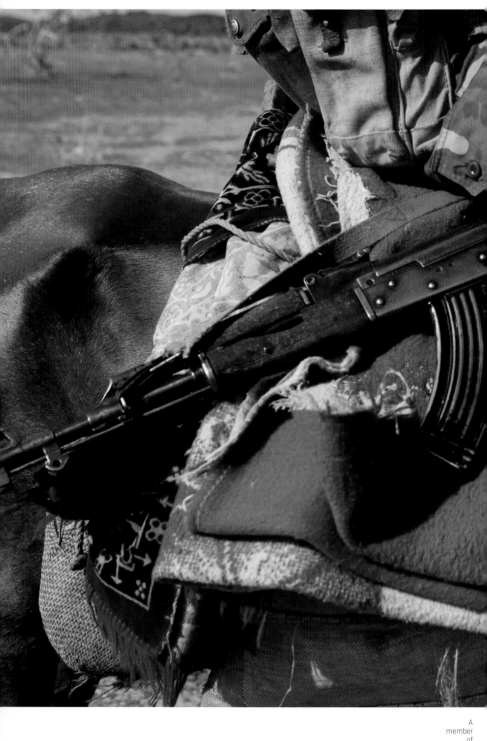

A
member
of
the
Janjaweed.

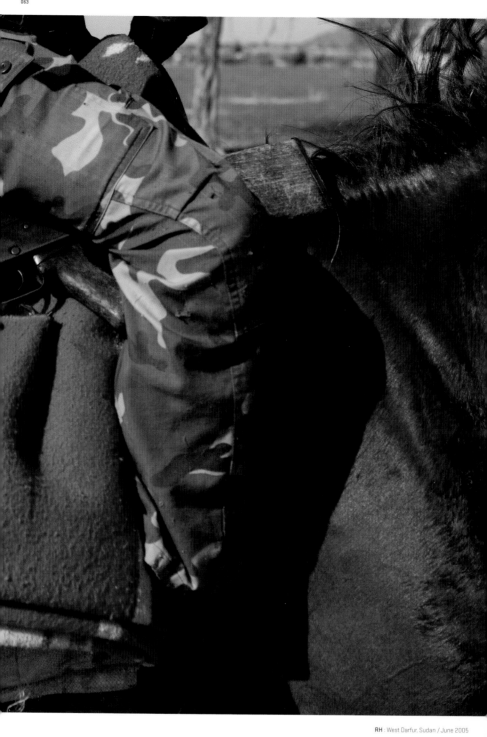

RH : West Darfur, Sudan / June 2005

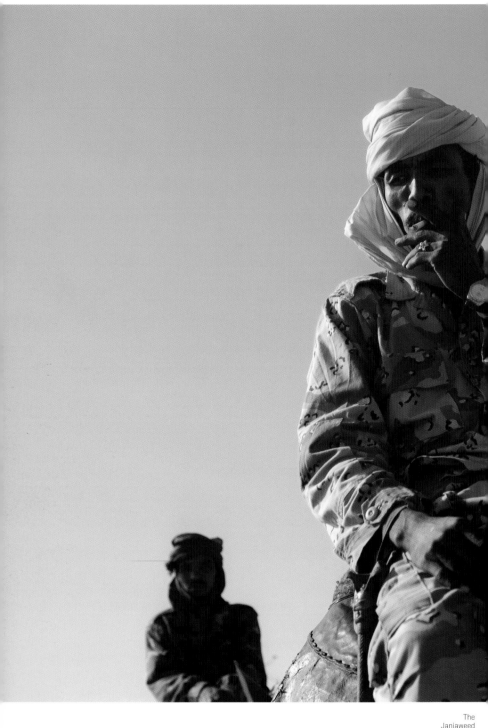

The
Janjaweed
check
on
their
cattle.

RH : West Darfur, Sudan / June 2005

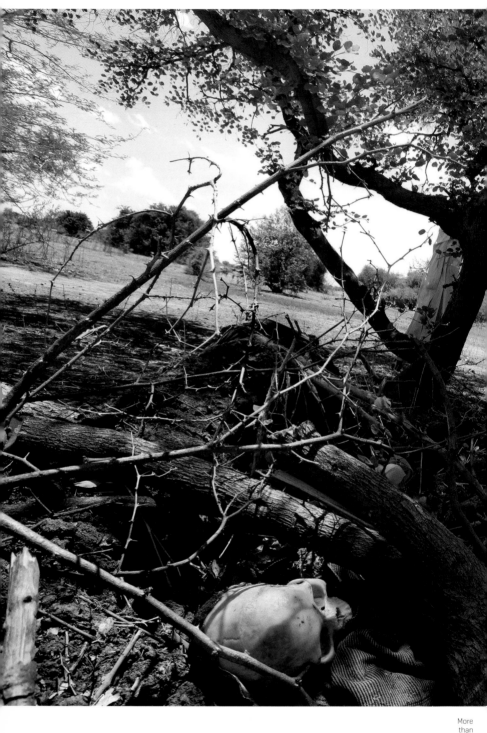

More
than
115
men
were
killed
when
Arab
militiamen
raided
this
village.

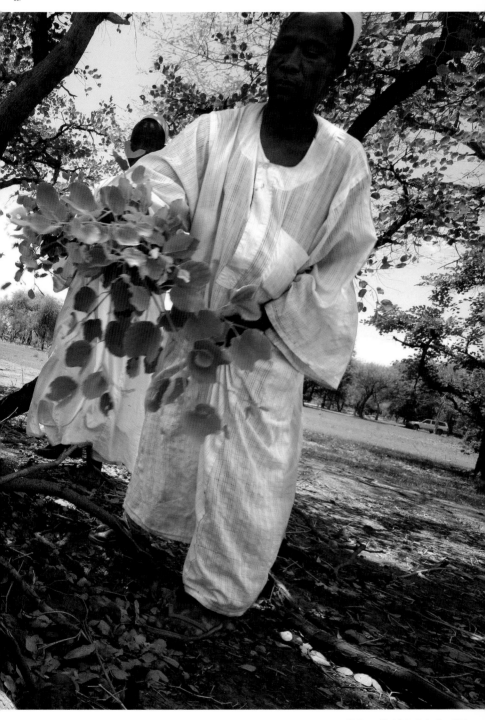

HC : Djawara, Chad–Sudan Border / June 2006

SLA soldiers pass by a dead body, a remnant of an attack in Farawyaiah in August 2004. Sixteen bodies were discovered in the surrounding ravines after five villages were destroyed by the Janjaweed.

African Union soldiers find the body of a young man in Tama more than a week after the village was attacked by Arab nomads in November 2005. The AU made several attempts to patrol Tama and conduct an investigation, but nomads took over the village and shot at any approaching vehicles.

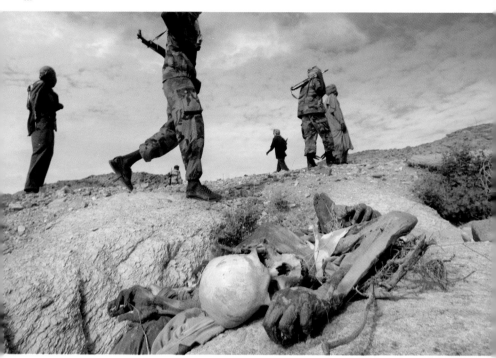

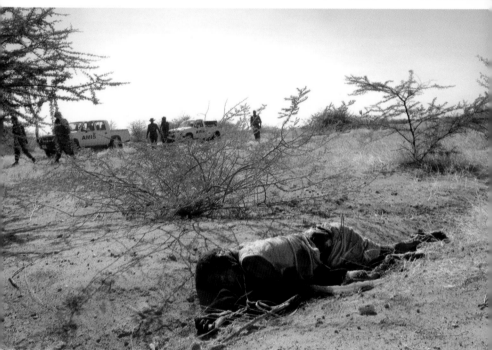

LA : Darfur, Sudan / August 2004
LA : Tama, Darfur, Sudan / November 2005

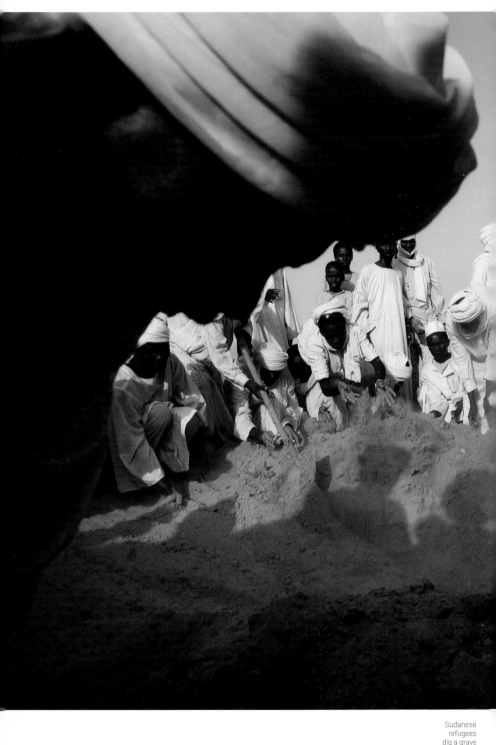

Sudanese refugees dig a grave after one of their own died at the Oure Cassoni Camp, about 7 kilometers from the Sudan border.

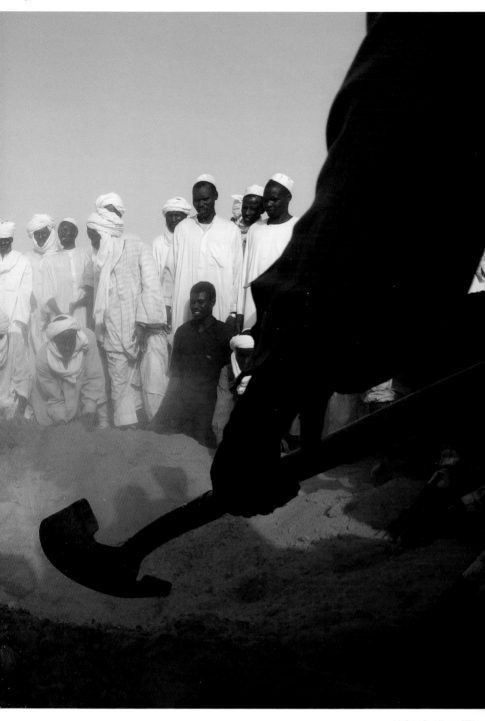

Friends
and
family
hold
a
funeral
for
a
woman
who
bled
to
death
during
childbirth.
She
was
unable
to go
to
the
hospital
in
government-
held
El Fasher
because
police
confiscated
the
ambulance.

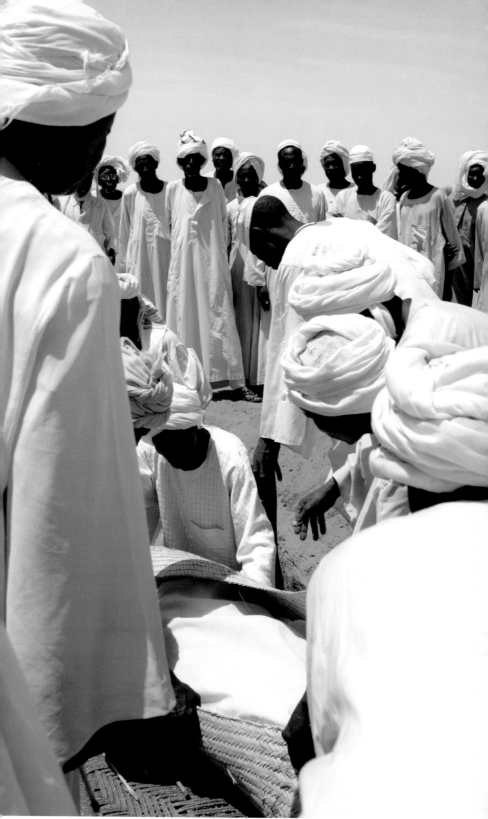

RH : North Darfur, Sudan / June 2005

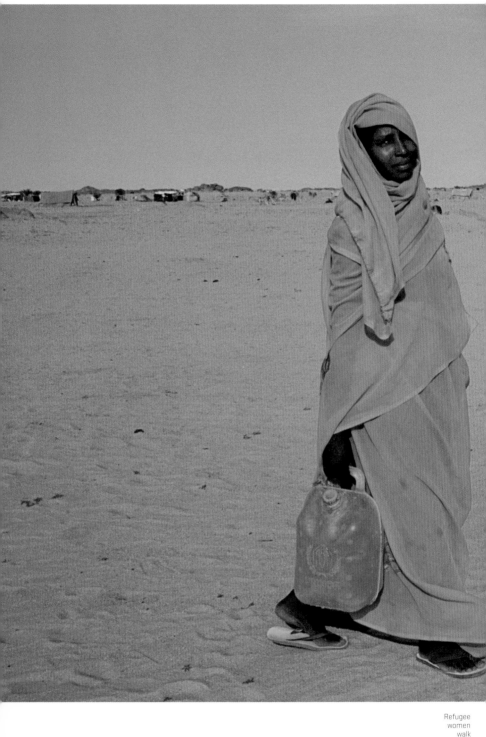

Refugee
women
walk
back
to
their
tents
after
filling
containers
at
a
water
distribution
center.

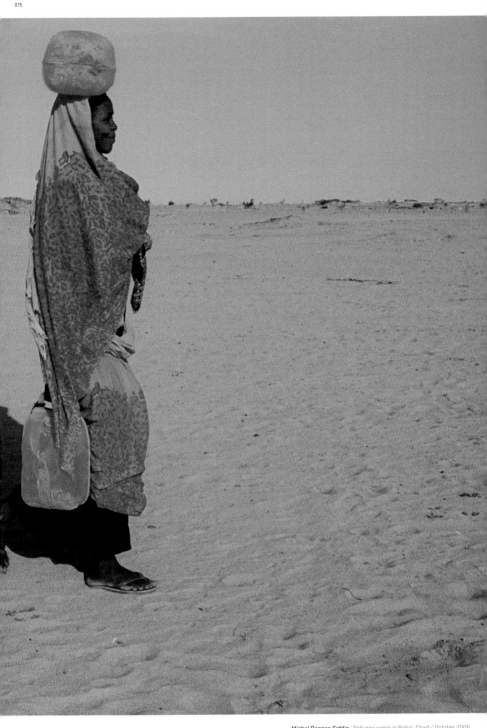

Michal Ronnen Safdie : Refugee camp in Bahai, Chad / October 2005

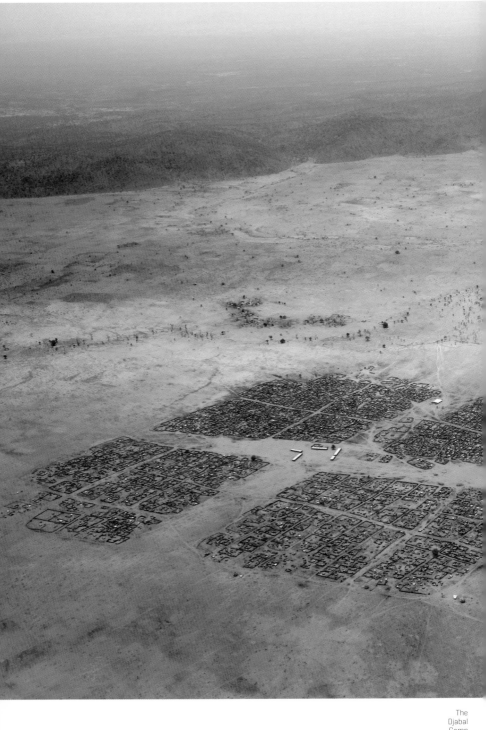

The
Djabal
Camp
is
home
to
more
than
15,000
refugees
from
Darfur.

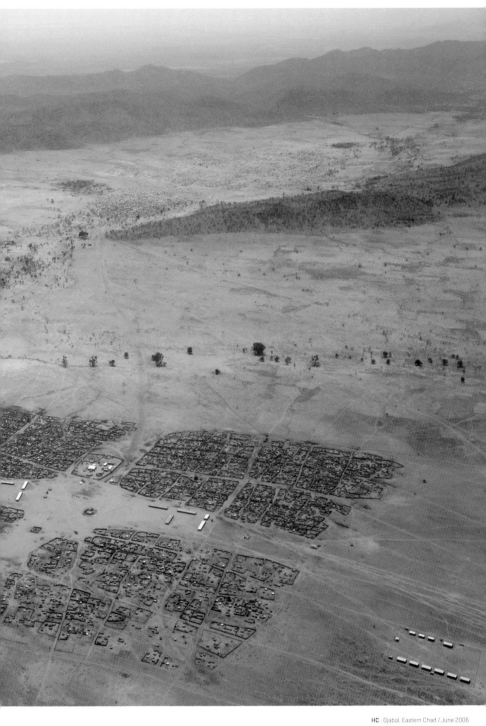

HC : Djabal, Eastern Chad / June 2006

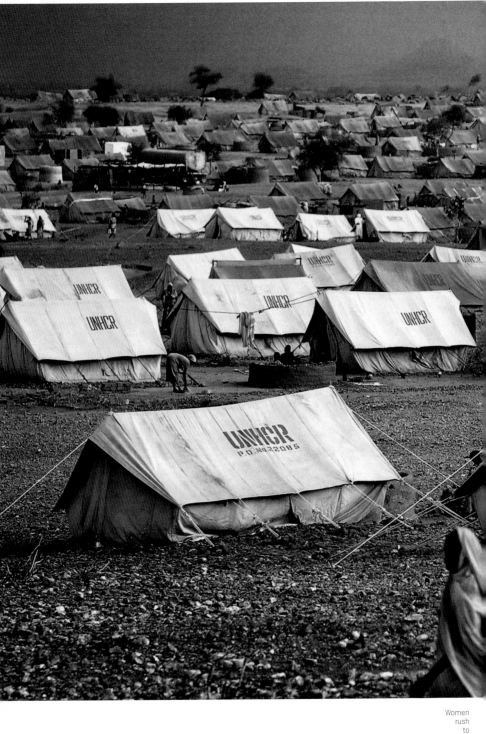

Women rush to finish chores as a storm approaches the Kounoungo Camp. Kounoungo has become home to more than 11,000 Sudanese refugees.

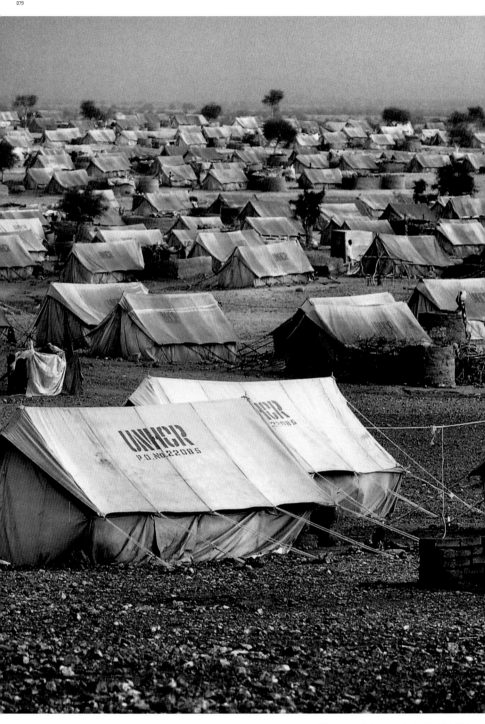

RSR : Kounoungo Refugee Camp. Eastern Chad / July 2004

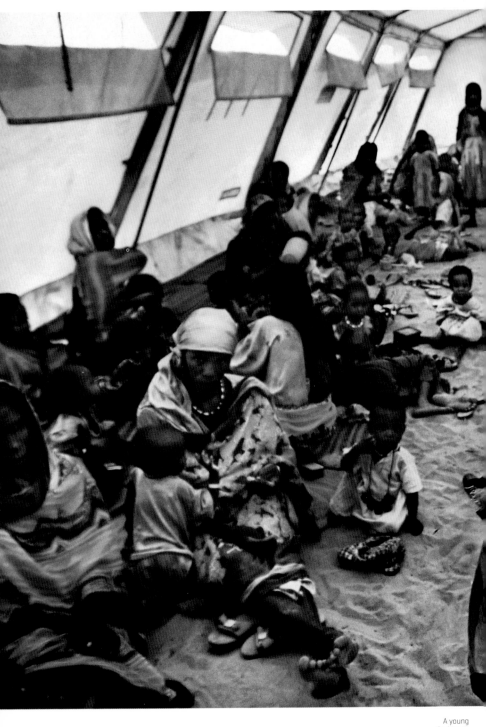

A young
Sudanese
girl walks
through the
Médicines
Sans Frontièrs
(MSF)
Clinic in the
Touloum Camp
of Eastern
Chad.
Touloum is
now
home to
more than
15,000
refugees.
Due to the
massive scale
of the
displacement,
few IDPs
have access to
health care.

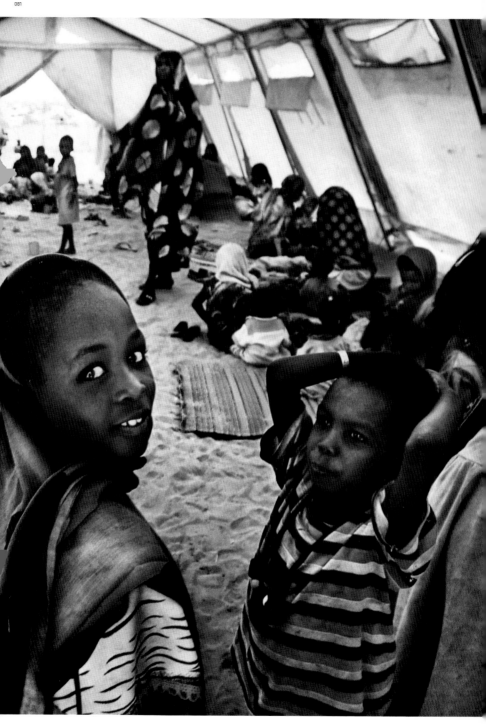

RSR : Touloum Refugee Camp, Eastern Chad / July 2004

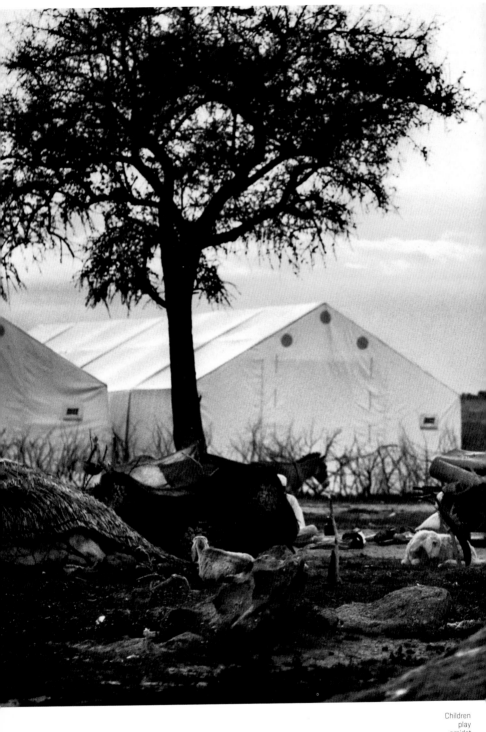

Children
play
amidst
the
displaced.

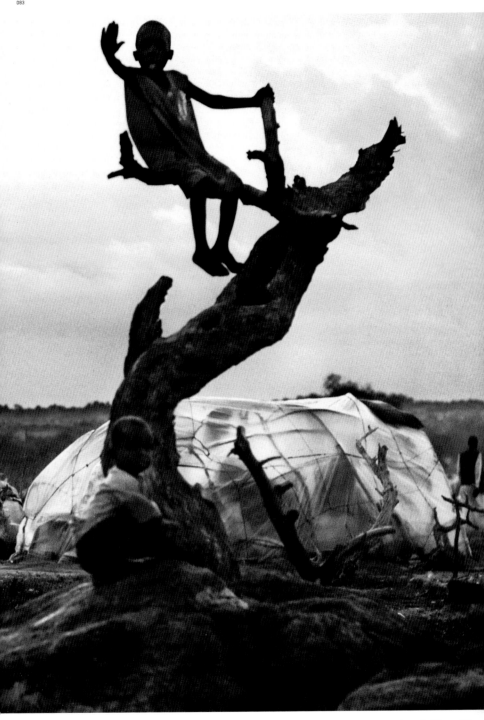

RSR : Bredjing Refugee Camp, Eastern Chad / August 2004

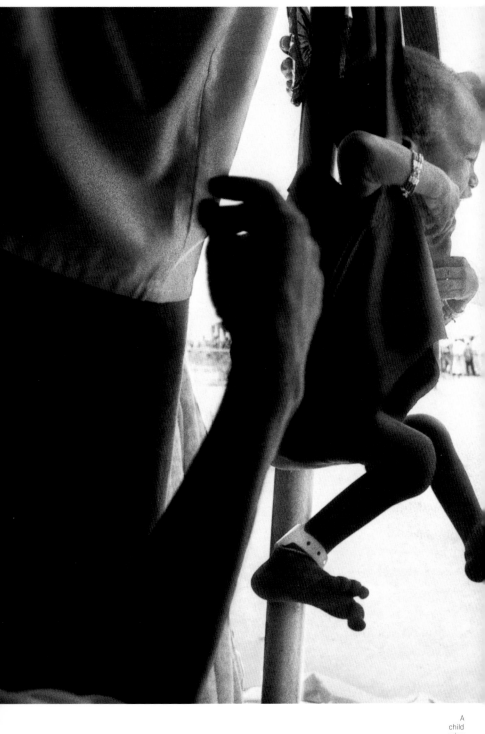

A child cries as nurses at the Mille Refugee Camp nutrition center weigh him. The medical center at this camp is managed by International Medical Corps (IMC).

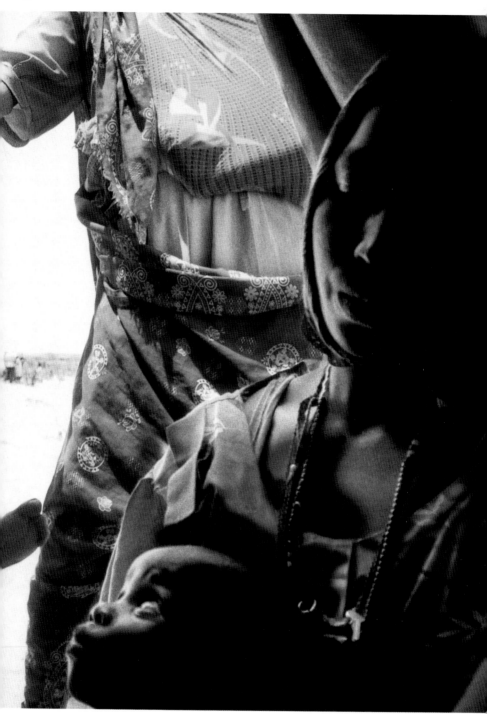

RSR : Mille Refugee Camp, Eastern Chad / July 2004

A worker toils in preparation for the monthly food distribution in the Touloum Refugee Camp. Distribution of food rations, provided by the World Food Programme, takes ten days to reach the camp's entire population.

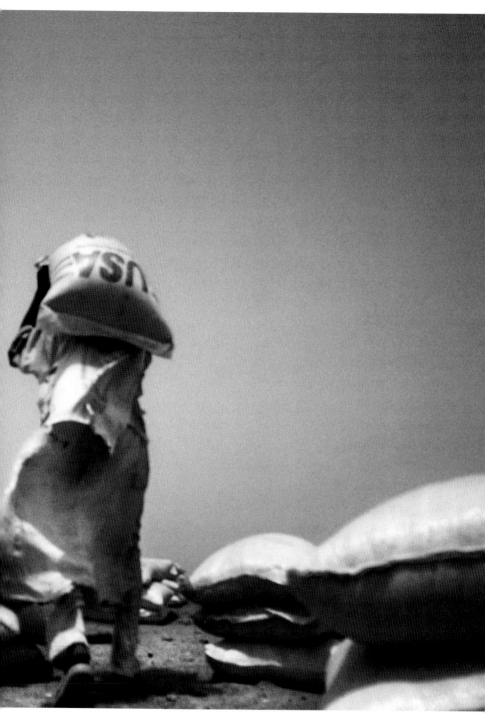

RSR : Touloum Refugee Camp. Eastern Chad / July 2004

DARFURDARFUR LIFE / WAR

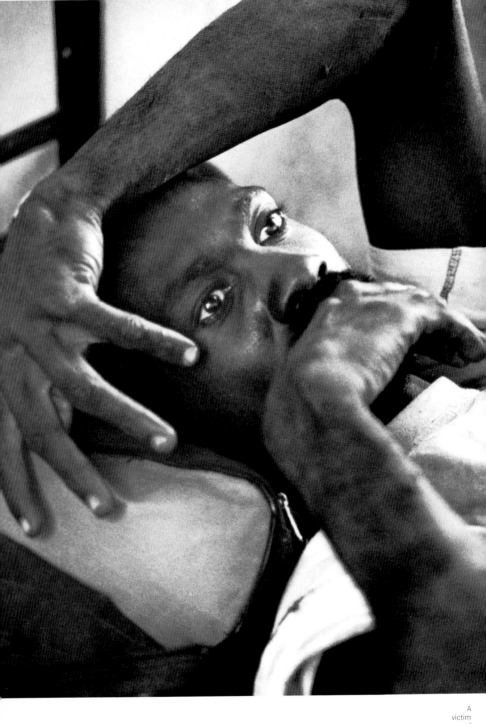

A
victim
of
the
Janjaweed,
this
man
recovers
from
gunshot
wounds
in
his
hospital
bed.

Mark Brecke : North Darfur, Sudan / October 2004

An
orphaned
child
with
his
grandmother.
His
father
was
killed
in
Darfur,
and
his
mother
died
in
childbirth.

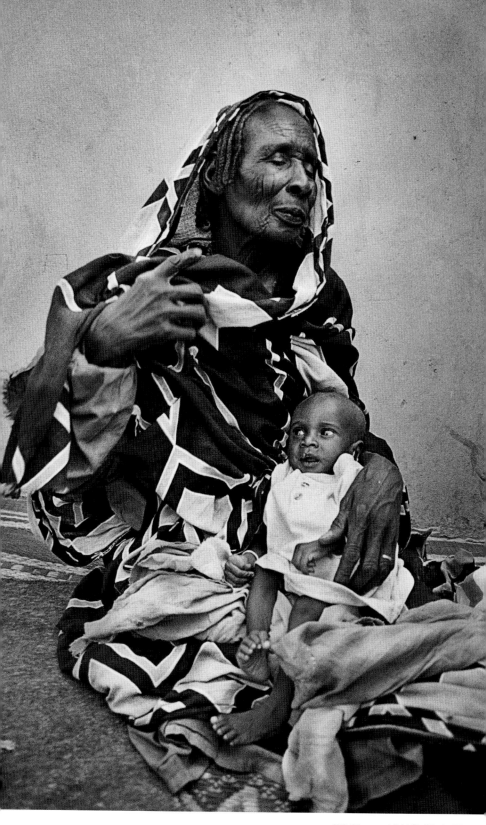

MRS : Refugee camp in Bahai, Chad / October 2004

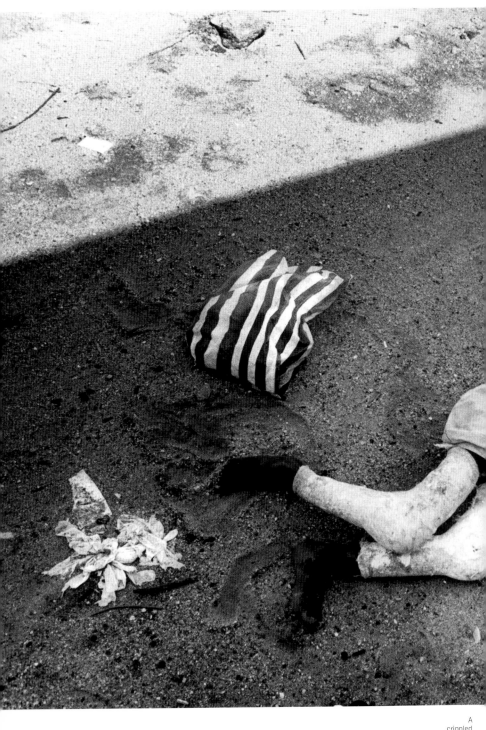

A
crippled
child
struggles
in
Nyala.

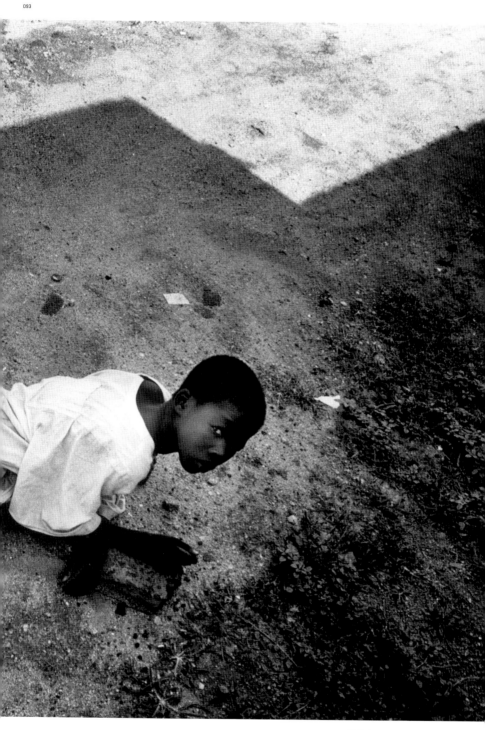

PP : Nyala, South Darfur, Sudan / Summer 2004

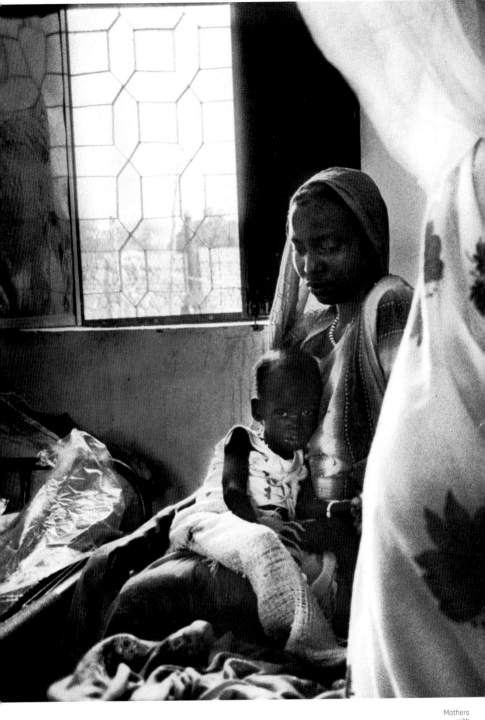

Mothers
with
malnourished
children
rely
on
MSF
to
help
feed
their
families.

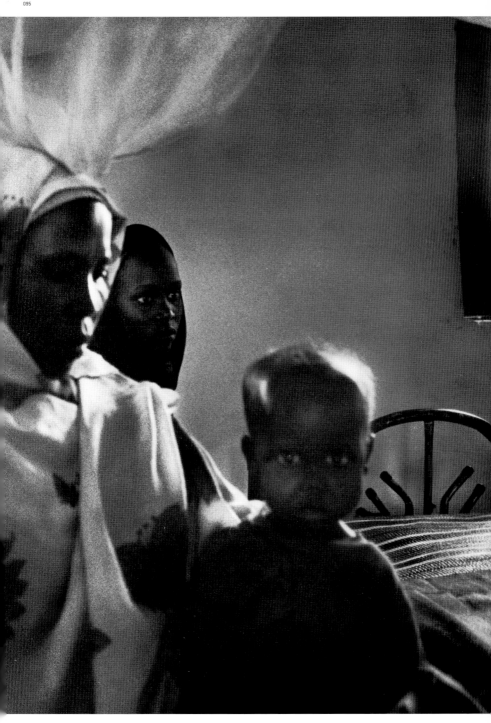

PP : South Darfur, Sudan / Summer 2004

Newly
arrived
persons
at
camps
in
Chad
have
been
occasionally
asked
by
local
authorities
to
swear
on
the
Koran
that
they
are
refugees
from
the
Darfur
conflict.

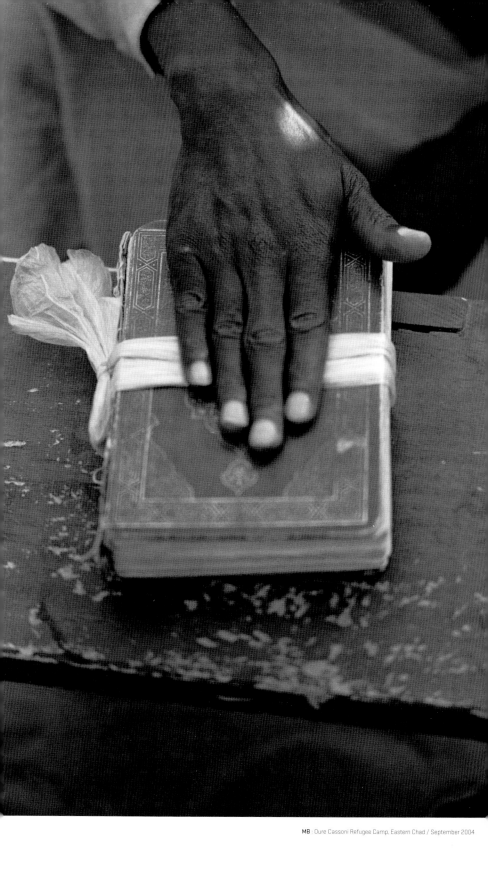

MB : Oure Cassoni Refugee Camp, Eastern Chad / September 2004

A
young
boy
glances
through
a
ripped
sheet
at
a
makeshift
camp
for
refugees.

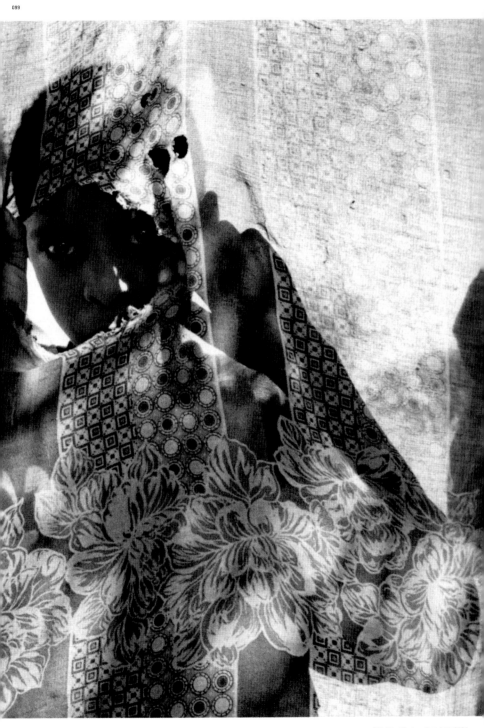

HC : Bahai, Eastern Chad / July 2004

A
displaced
boy
searches
for
water
as
his
donkey
and
goat
wander
around.

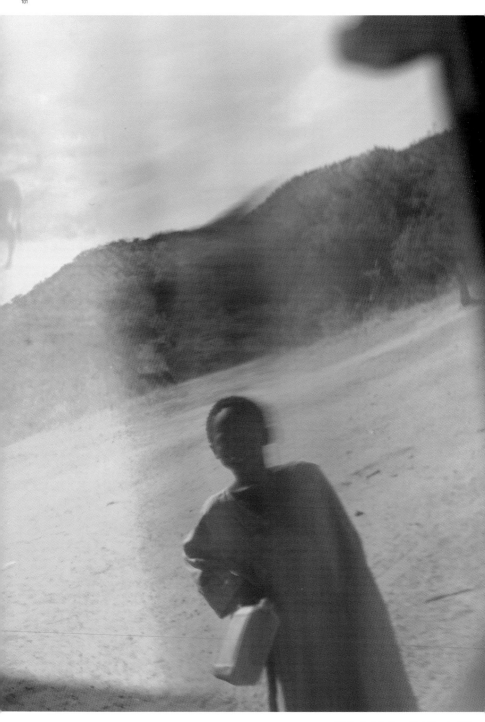

HC : Near Goz Beida, Eastern Chad / November 2006

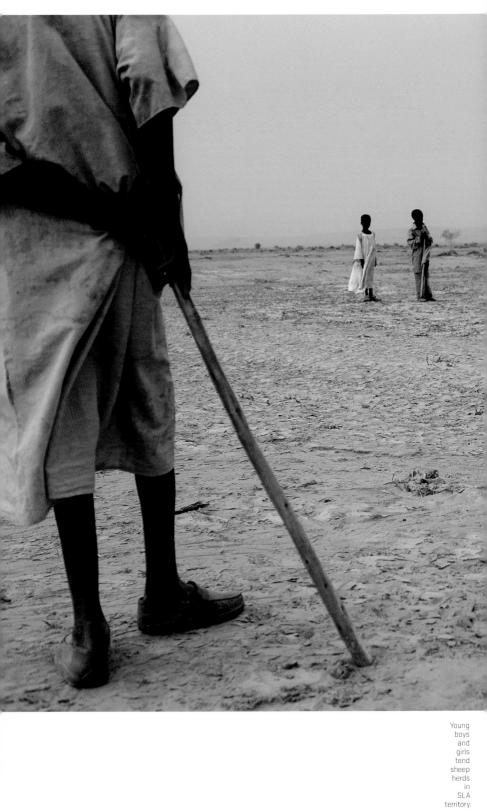

Young
boys
and
girls
tend
sheep
herds
in
SLA
territory.

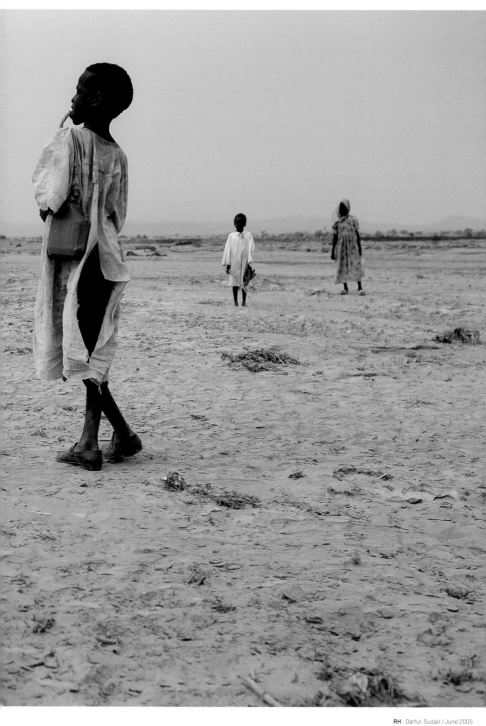

RH : Darfur, Sudan / June 2005

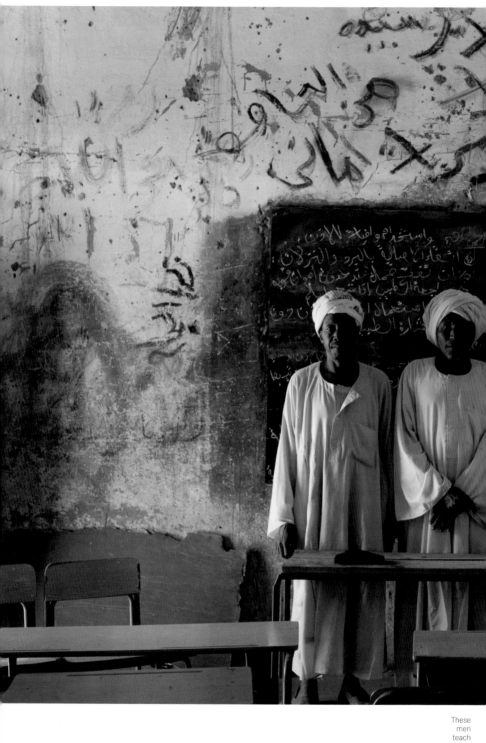

These
men
teach
children
at
a
school
run
in
an
SLA
controlled
area.

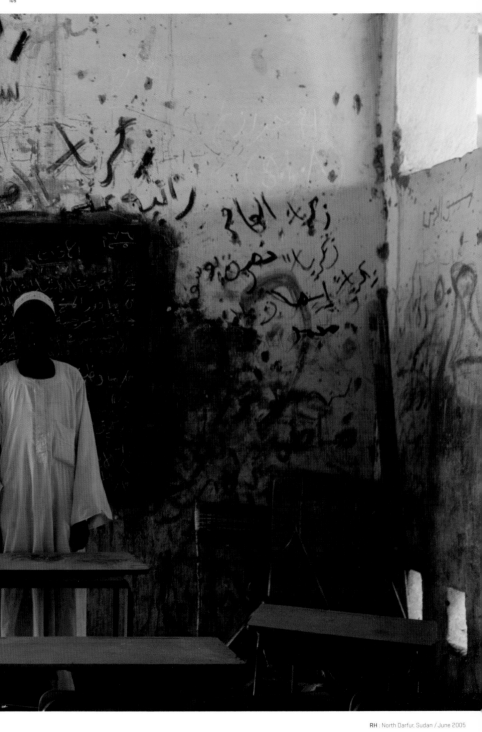

RH : North Darfur, Sudan / June 2005

The people
of the
mountainous
Jebel Moon
area
receive little
support
from the
international
community.
The area,
which is
controlled
by various
rebel
groups
and often
attacked,
has seen
cases of
polio
among its
many sick
children.

RH : West Darfur, Sudan / June 2005

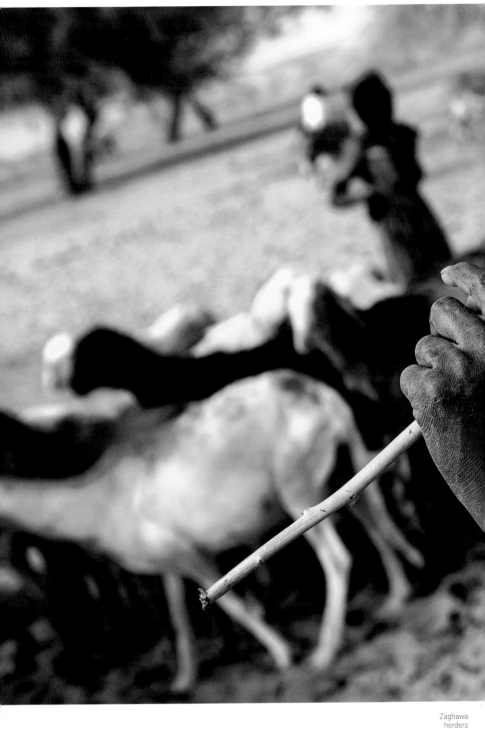

Zaghawa
herders
move
their
animals
during
the
rainy
season.

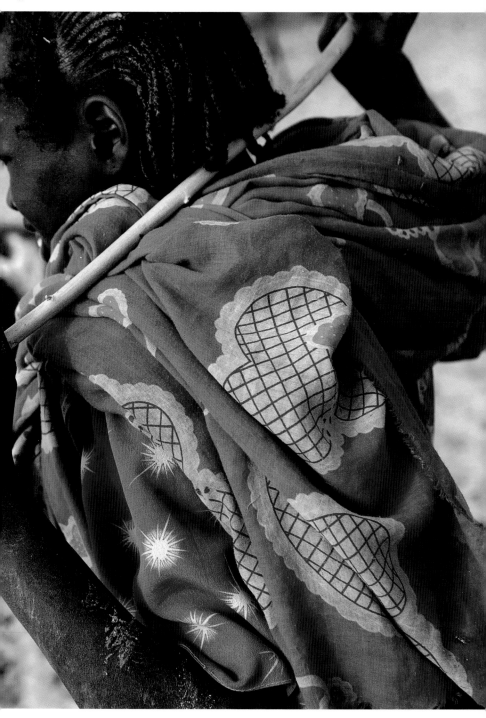

RH : West Darfur, Sudan / June 2005

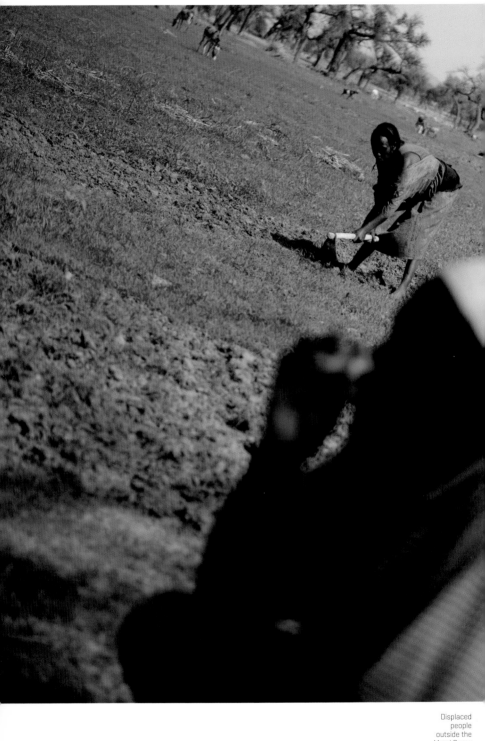

Displaced
people
outside the
Morni Camp
plant
crops
for future
harvest.
If they
pay
a special
tax
or hand
over
a portion
of their
crops
to the
Janjaweed,
they
will be
allowed
to harvest
in the fall.

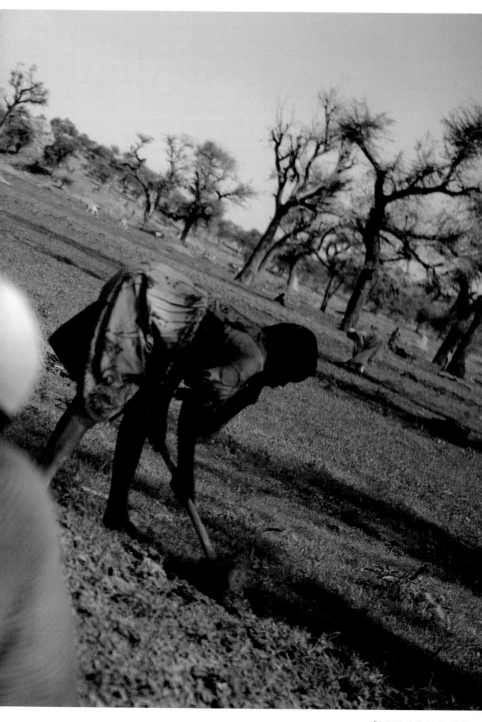

RH : West Darfur, Sudan / June 2005

Only
one
man
and
his
daughter,
ten-
year-
old
Hawa,
have
returned
to
try
to
live
in
their
destroyed
village.

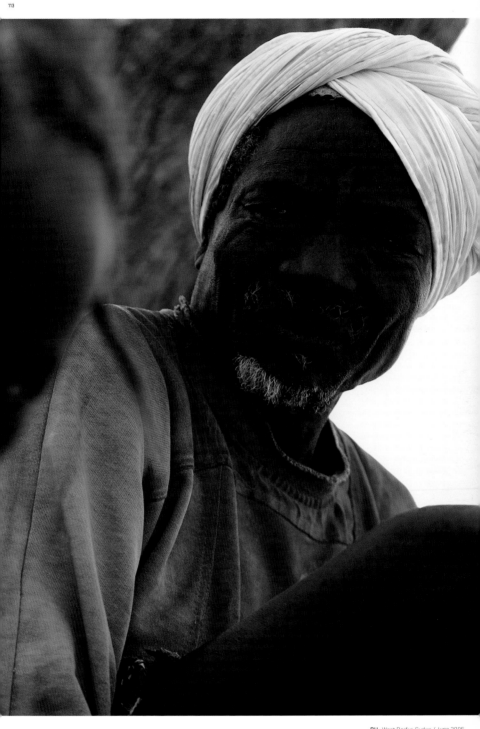

RH : West Darfur, Sudan / June 2005

A
school
in
SLA
territory.
Classes
are
held
in
a
building
with
a
damaged
roof.

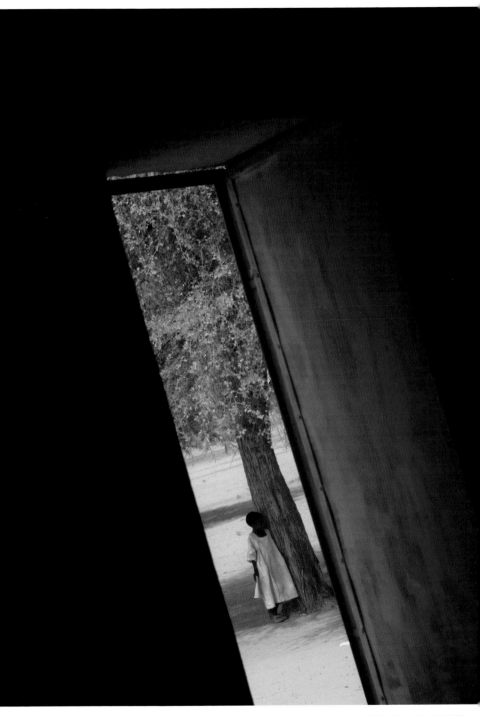

RH : North Darfur, Sudan / June 2005

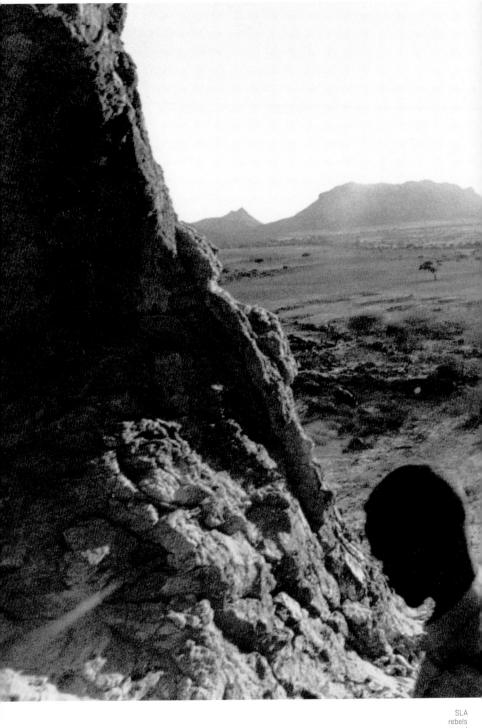

SLA
rebels
travel
throughout
the
mountainous
desert
in
Darfur.

MB : Near Sanihaya, North Darfur, Sudan / September 2004

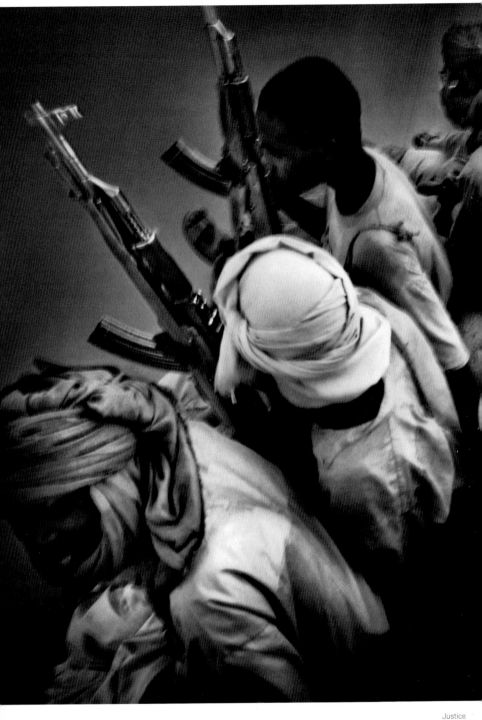

Justice
Equality
Movement
(JEM)
rebels
patrol
deserted
villages
from
the bed
of a
pickup
truck.

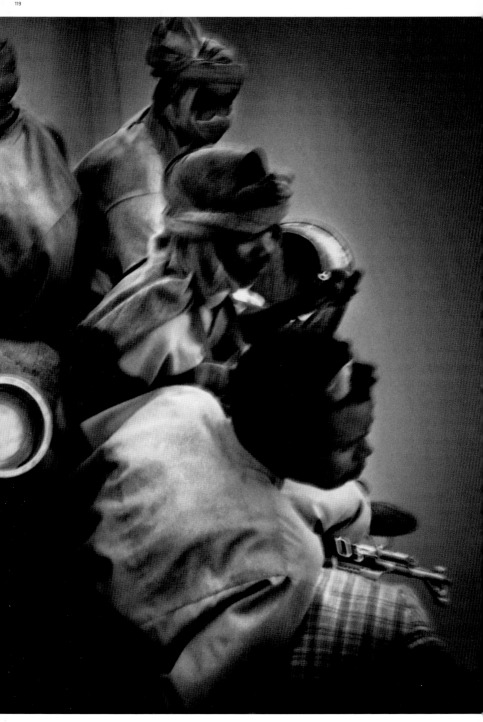

RSR : Patrol road, Northern Darfur, Sudan / August 2004

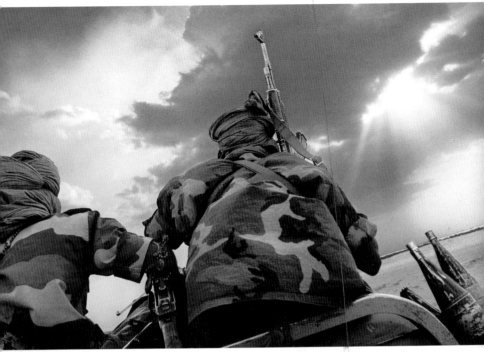

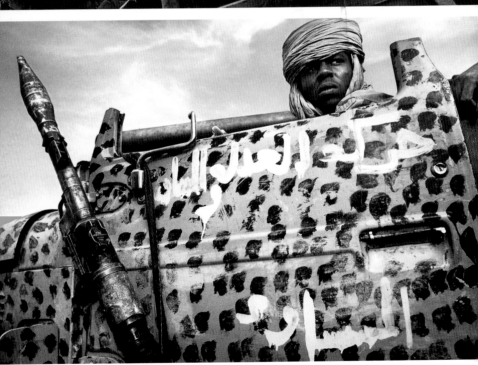

RSR : Patrol Road, North Darfur, Sudan / August 2004
JEM rebels patrol villages vacated by IDPs.
RSR : Rebel Encampment, North Darfur, Sudan / August 2004
A JEM soldier sits in an old Toyota Land Cruiser, which has been
modified to carry heavy artillery.

RSR : Rebel encampment, North Darfur, Sudan / August 2004
One of the youngest members of the JEM rebels patrols a hill
overlooking the Sudan-Chad border.
RSR : Rebel encampment, North Darfur, Sudan / August 2004
Commander Abdel Karim of the JEM prepares a rocket-propelled
grenade on a hill overlooking the Sudan-Chad border.

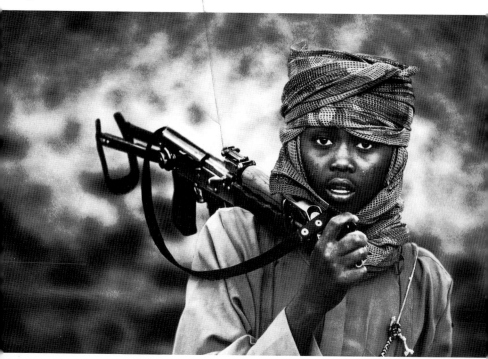

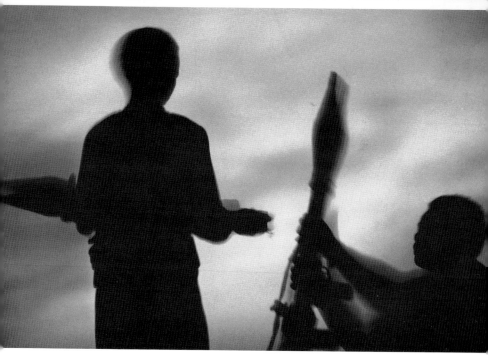

A tense SLA rebel stands guard following a Sudanese army ambush.

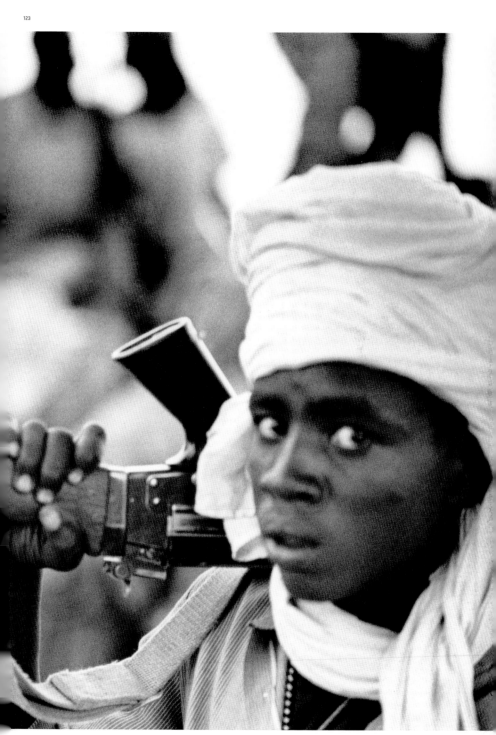

MB : Mellit, North Darfur / November 2004

An
SLA
fighter
wears
sashes
of
leather
amulets
known
as
hijab,
which
are
believed
to
protect
one
from
harm.

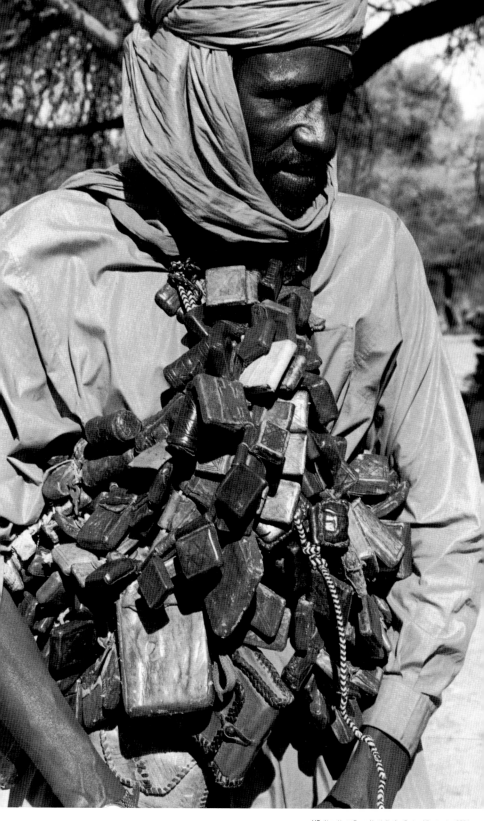

MB : Near Umm Berro, North Darfur, Sudan / September 2004

The
SLA
joined
forces
together
in
August
2001
and
launched
its
rebellion
in
early
2003.

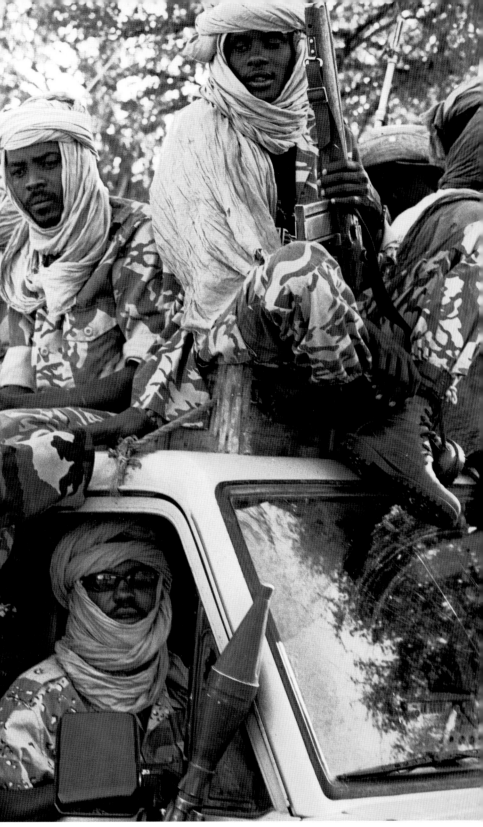

MB : Near Umm Berro, North Darfur, Sudan / September 2004

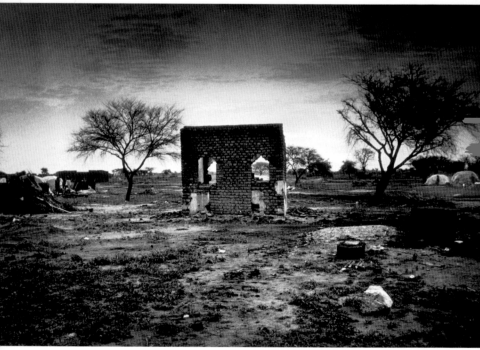

LEFT TOP TO BOTTOM
PP : South Darfur, Sudan / Summer 2004
This destroyed village lies outside of Kalek.
PP : Near Nyala, South Darfur, Sudan / Summer 2004
This village is one of thousands that have been destroyed by the
Janjaweed.

RIGHT TOP TO BOTTOM
MB : Ankaa, North Darfur, Sudan / December 2004
One hundred families once lived in this village in Ankaa.

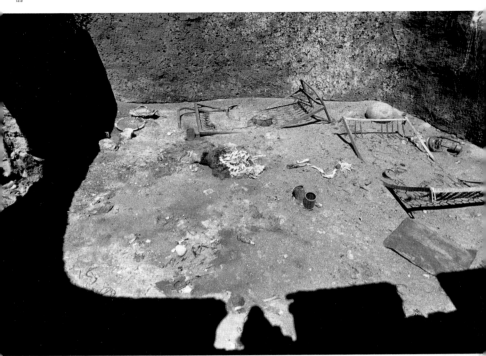

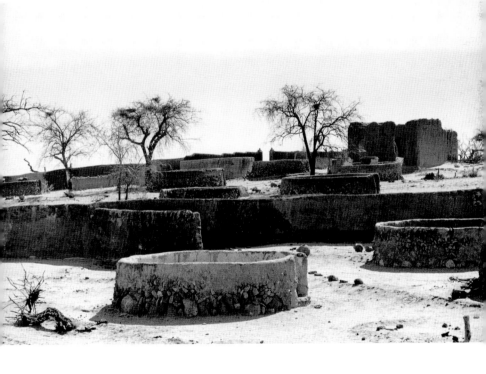

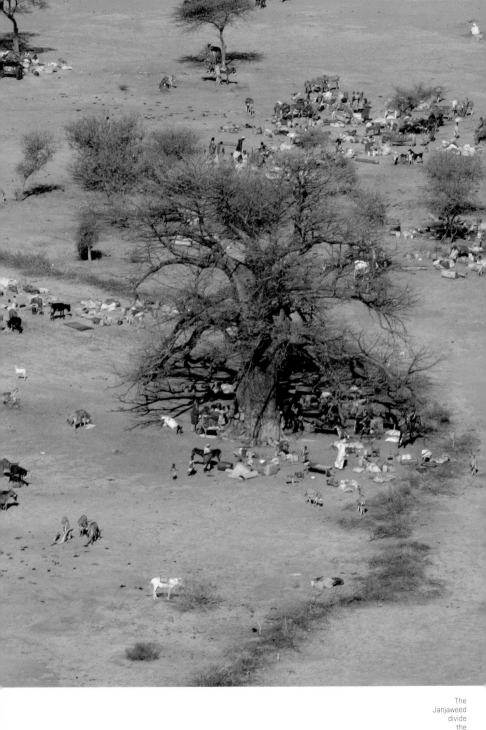

The
Janjaweed
divide
the
loot
they
collected
from
a
raid
of
Um
Ziefa.

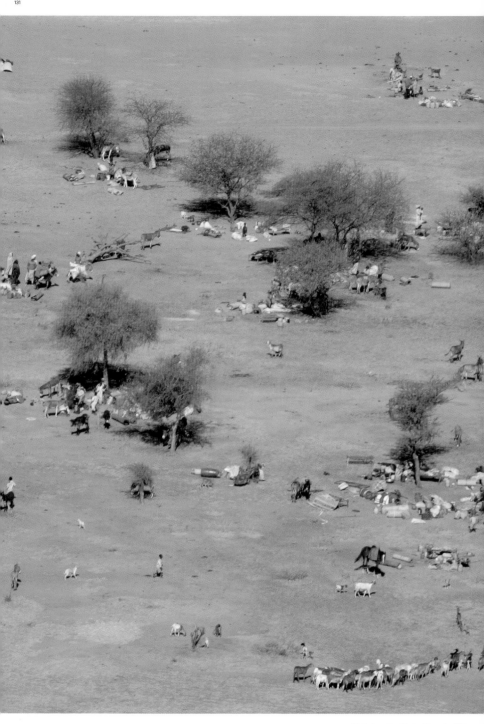

BS : Konkono, South Darfur / December 2004

Women
and
children
outside
a
refugee
camp
waiting
to
be
admitted.

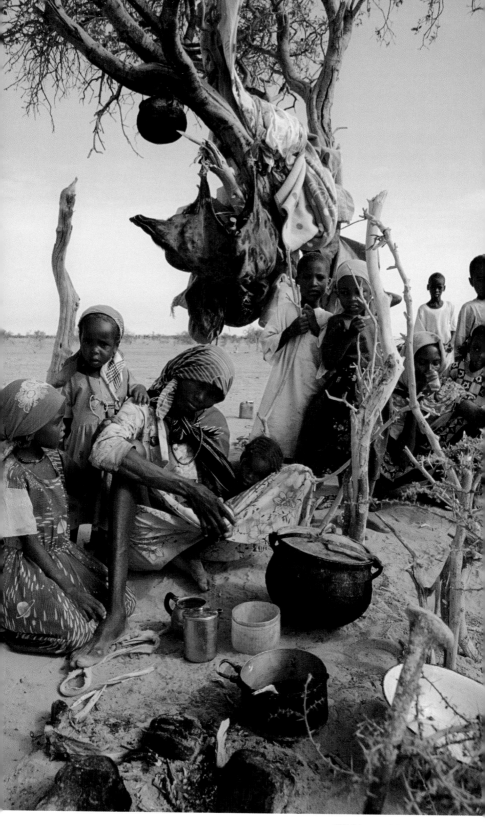

MRS : Refugee camp in Bahai, Chad / October 2004

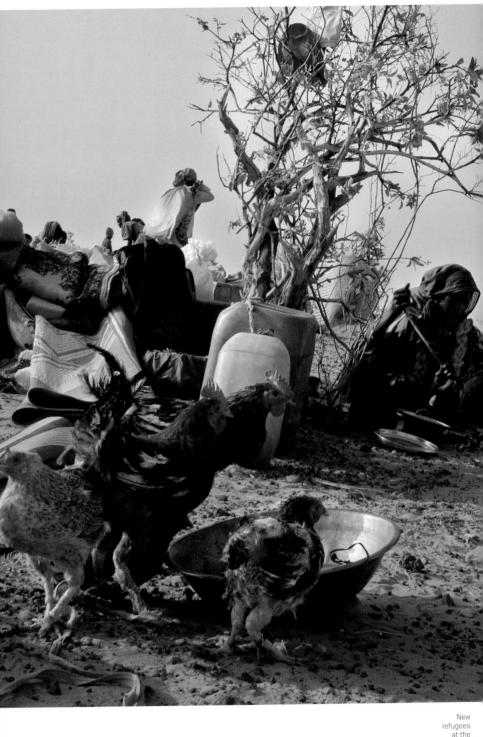

New refugees at the Touloum Camp will be registered by the UNHCR before moving to a transit center with food, water, and shelter. Most of the newcomers walked from the border town of Tine after hearing about the camp.

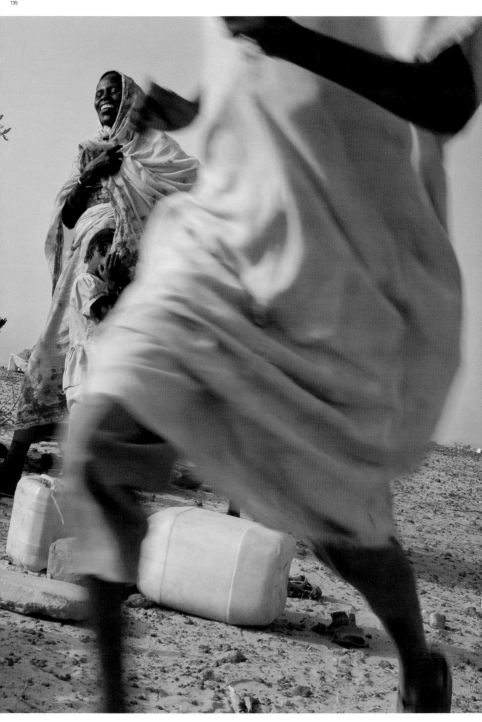

HC : Touloum Camp, Eastern Chad / April 2004

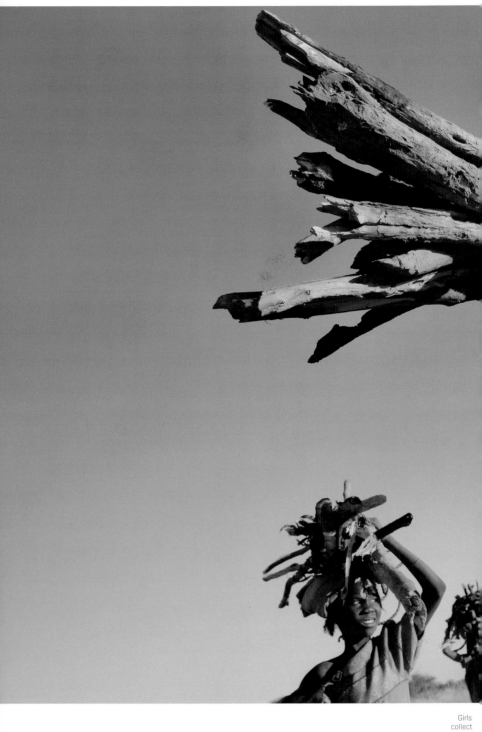

Girls collect wood in Habile, a village that was attacked and burned by armed militia.

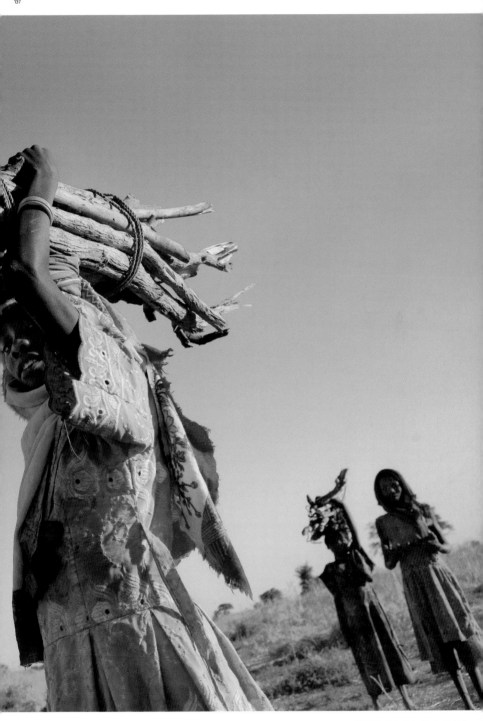

HC : Habile, Darfur, Sudan / December 2006

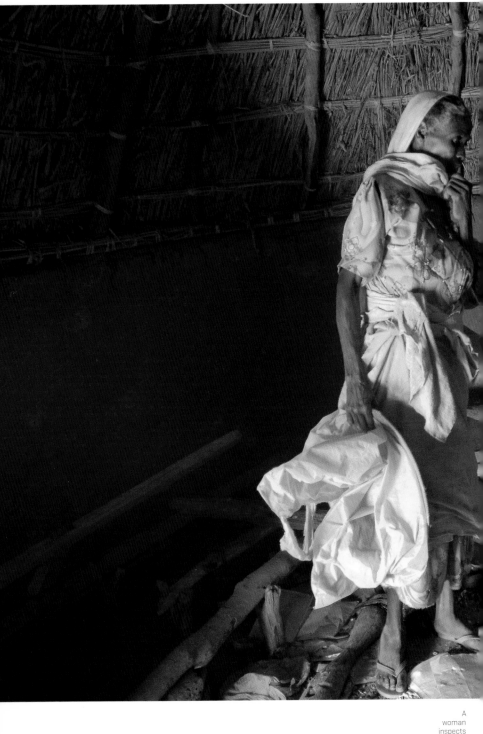

A woman inspects her hut after her village was attacked. About 40 people died in the massacre, and survivors retreated to a nearby village.

LA : Darfur, Sudan / November 2005

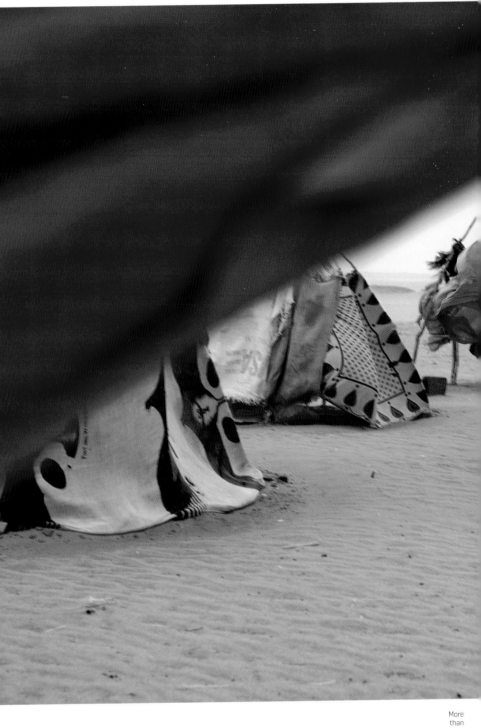

More
than
70,000
IDPs
reside
at
the
camp
and
hundreds
more
arrive
each
week,
often
with
little
support
for
survival.

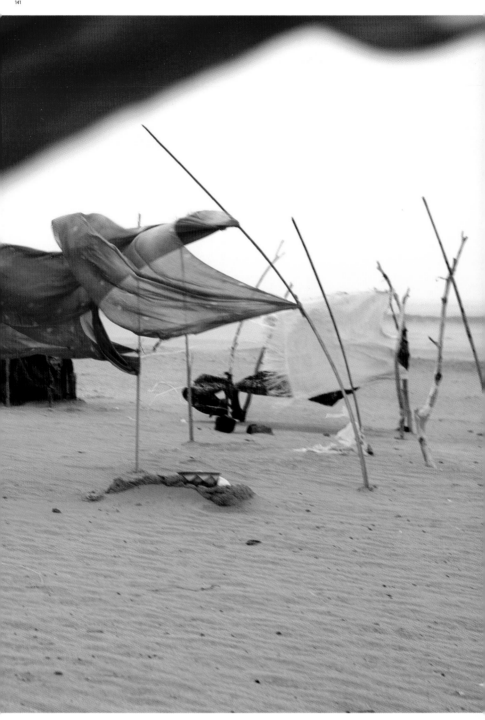

RH : Abu Shouk, North Darfur, Sudan / June 2005

A
Sudanese
woman
sits with her
granddaughter
the week
after
her husband,
the local
imam,
was killed
in front of
them in
the mosque
at Tama.
After the
attack,
the woman
and her
granddaughter
fled to her
son's home
in Nyala.

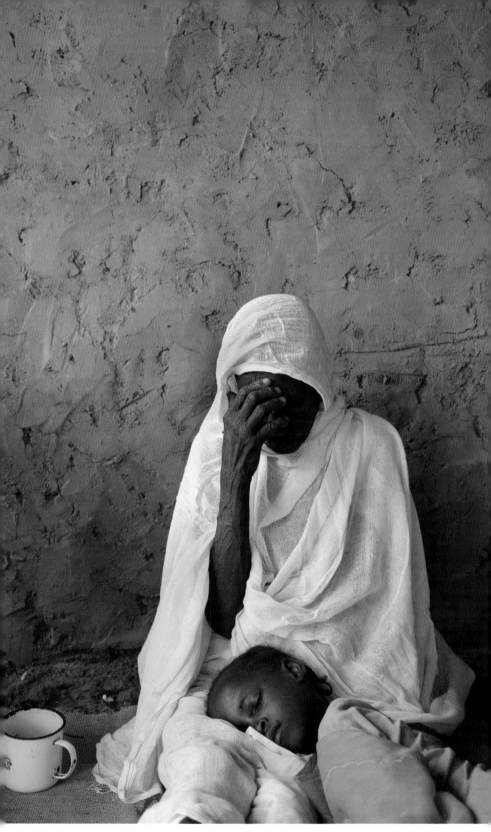

A
12-year-old
girl
(wearing
the
striped
scarf)
explains
how
she
was
separated
from
her
two
friends
and
raped
by
soldiers
from
the
Sudanese
government.

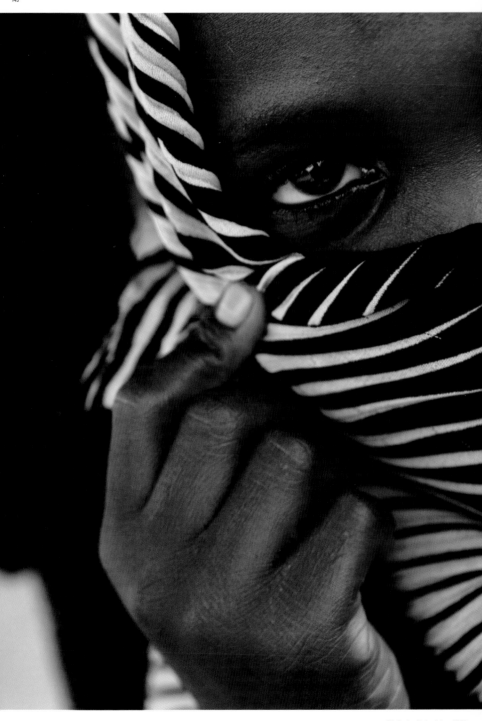

RH : Darfur, Sudan / June 2005

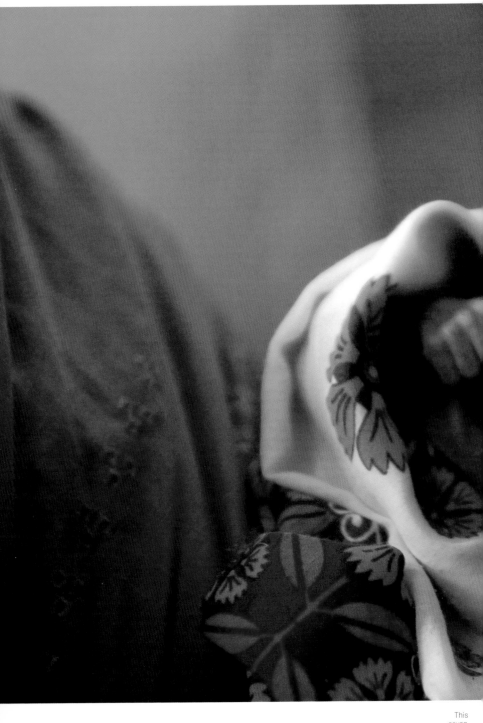

This seven-week-old boy, who is battling malnutrition and intestinal blockage, is X-rayed in a government hospital.

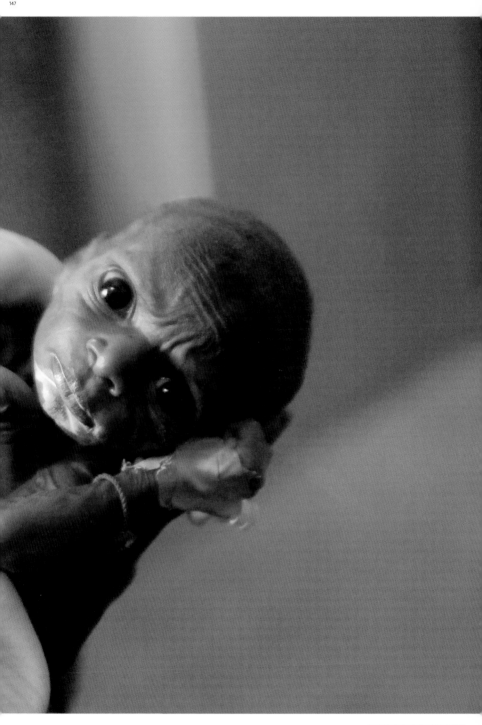

LA : West Darfur, Sudan / March 2007

A
girl
in
a
refugee
camp
who
was
injured
during
a
bombing
raid
in
Darfur.

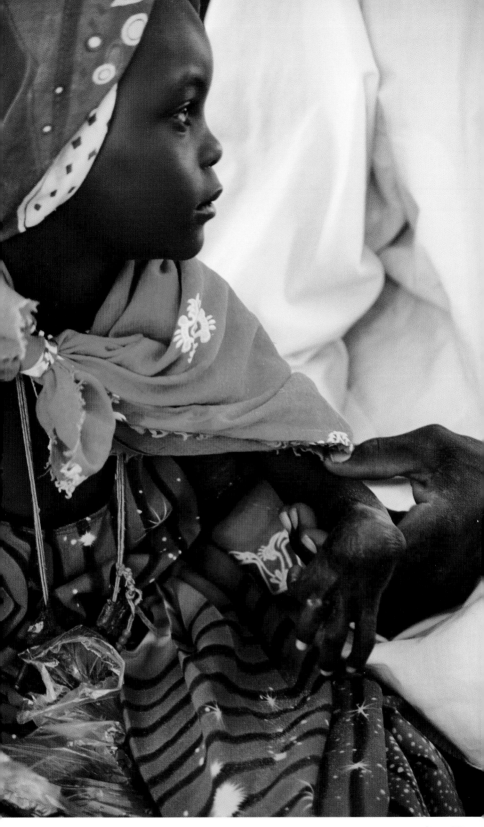

MRS : Bahai, Chad / October 2004

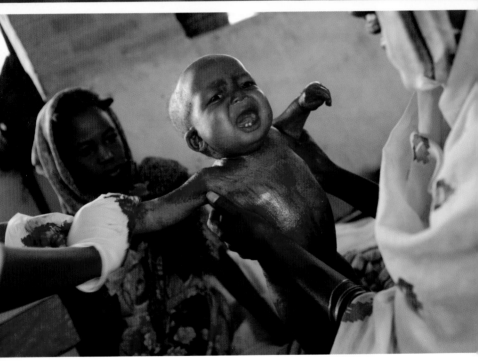

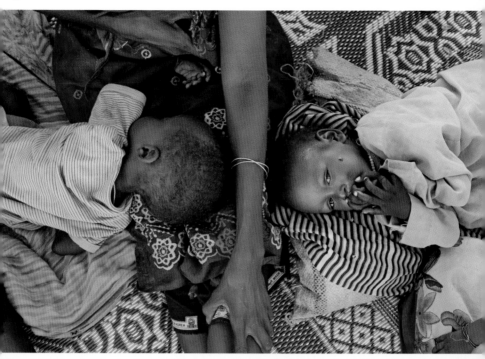

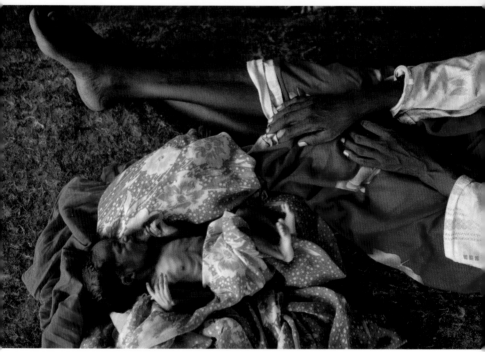

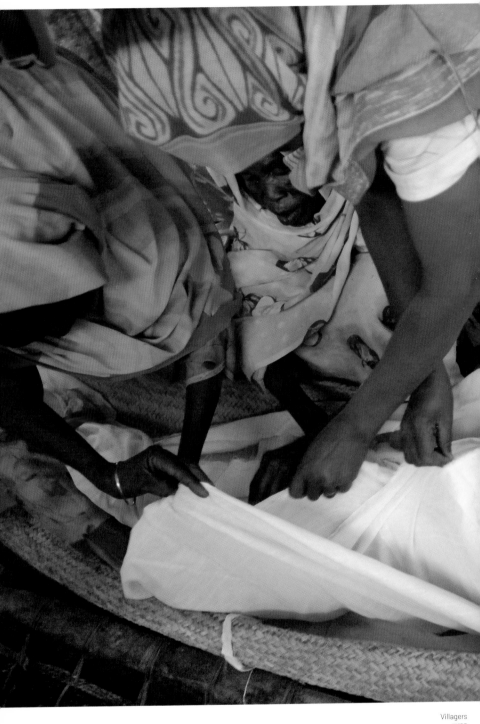

Villagers
wrap
the
body
of
an
old
woman
before
her
burial
in
the
Kalma
Camp
for
IDPs.

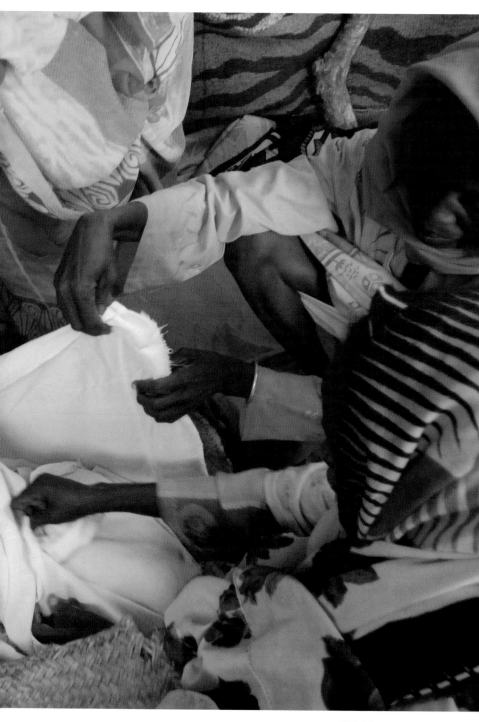

LA : Nyala, South Darfur, Sudan / November 2005

A young Chadian girl tries to push back tears when talking about her father and two brothers, who were killed by the Janjaweed militia in Chad.

155

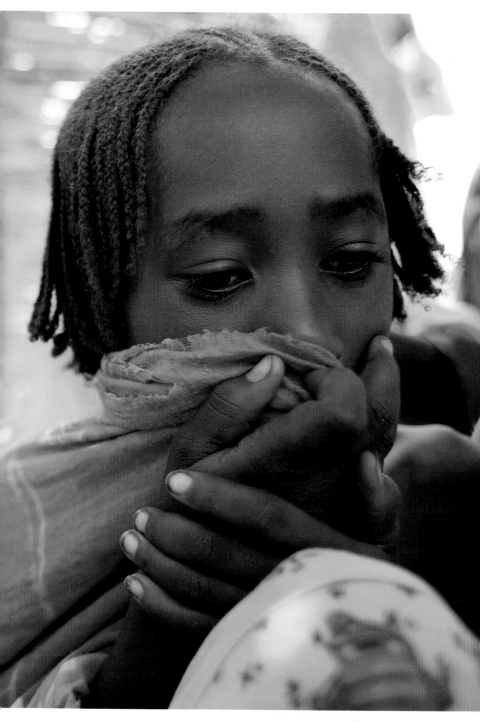

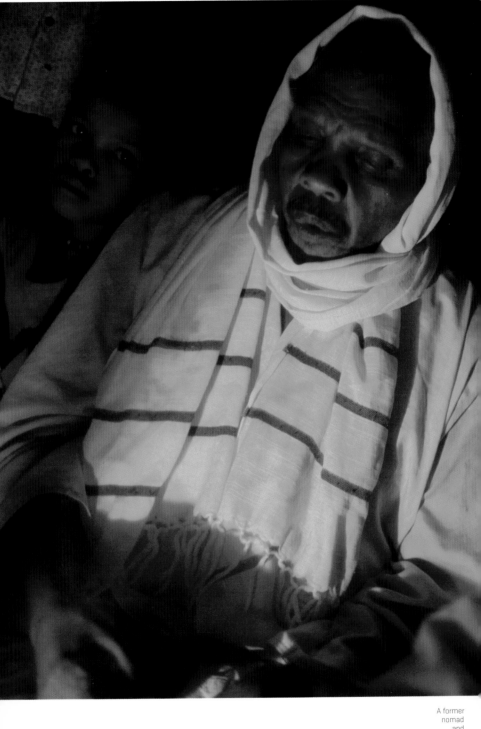

A former nomad and herder tells how after his son was killed by the SLA, he was forced to care for the son's grieving family, including 20 children. He says he went blind from the trauma.

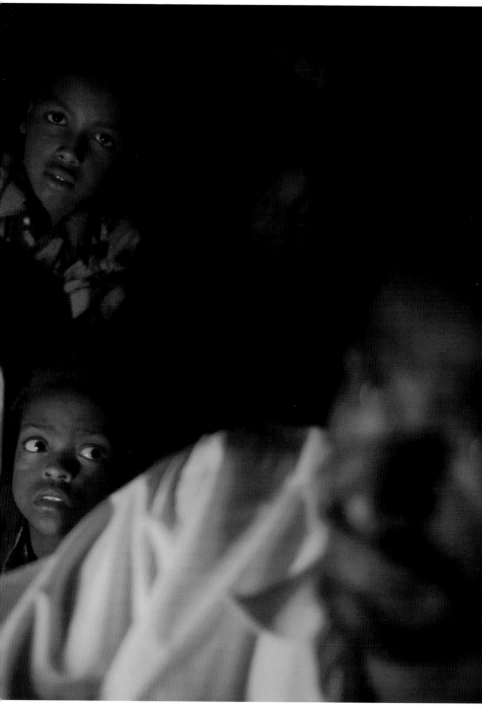

RH : North Darfur, Sudan / June 2005

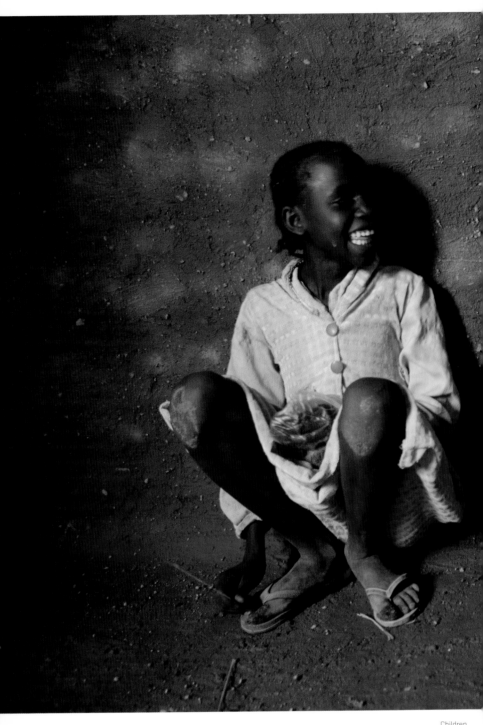

Children
play
at
a
camp
for
IDPs.

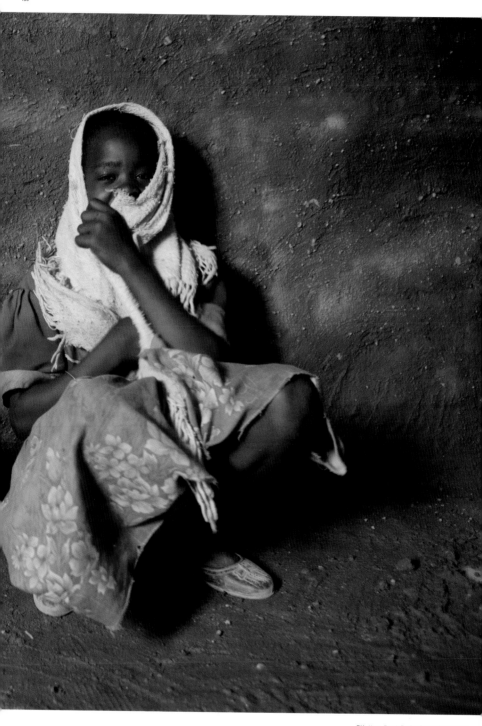

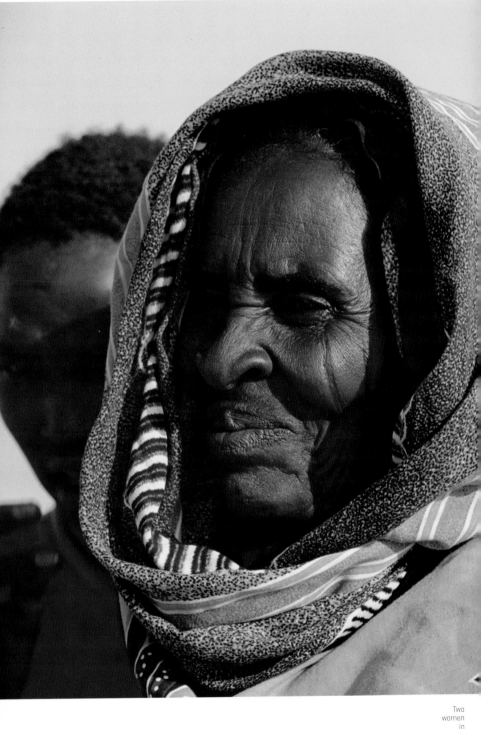

Two
women
in
a
refugee
camp
who
have
been
victims
of
violence.

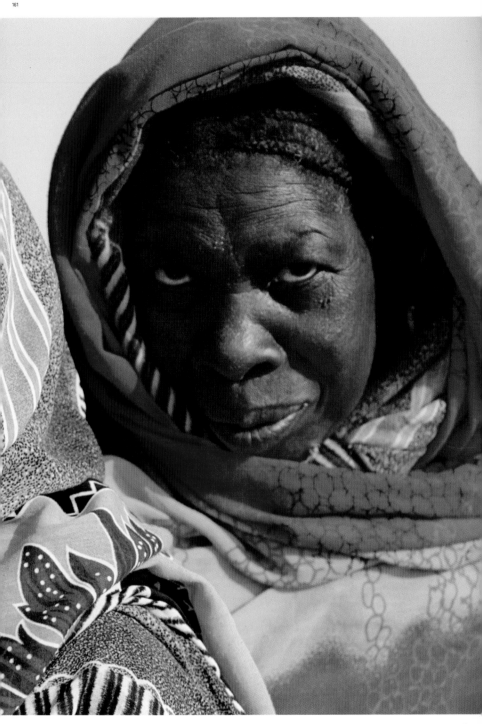

MRS : Bahai, Chad / October 2004

IDP women gather in Seliah camp to talk to UNHCR officials about their living conditions.

A group of men in the Bahai refugee camp in Chad.

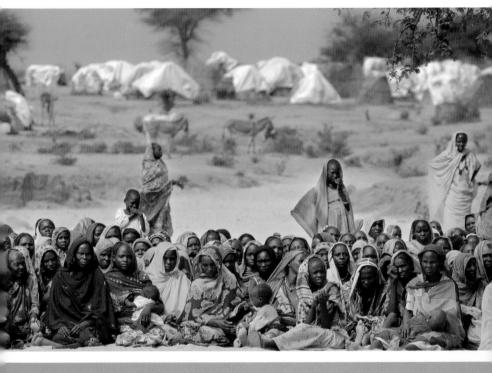

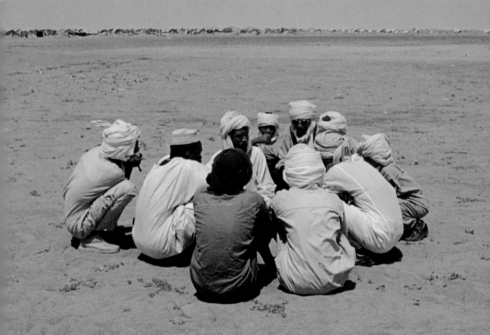

HC : Seliah, Darfur / September 2004
MRS : Bahai, Chad / October 2004

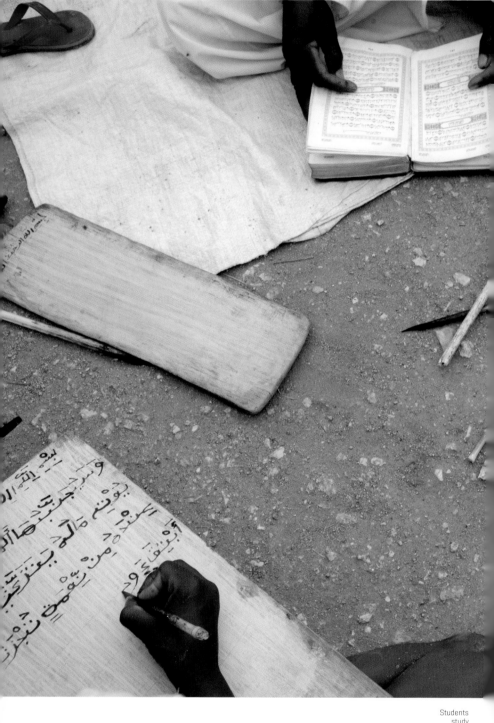

Students
study
the
Koran
at
the
Morni
Camp.

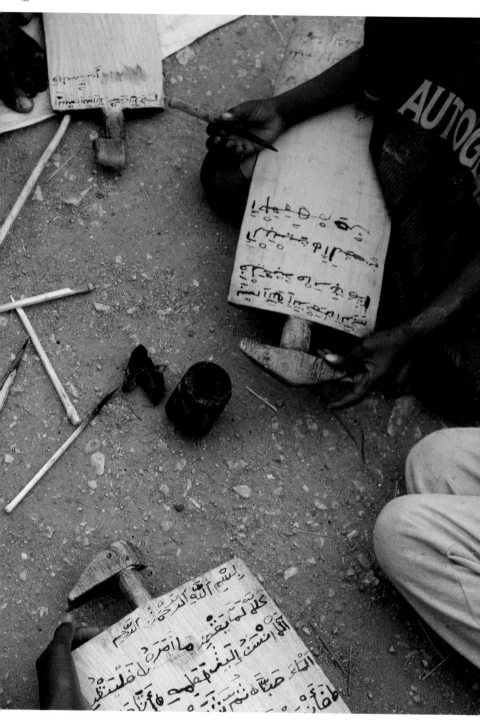

RH : West Darfur, Sudan / June 2005

Students
learn
at a
school
where books
are
scarce,
and
some
classes
are
comprised of
nearly
100
children.
More
than
ten
students
request to
be
taken to a
clinic
each day.

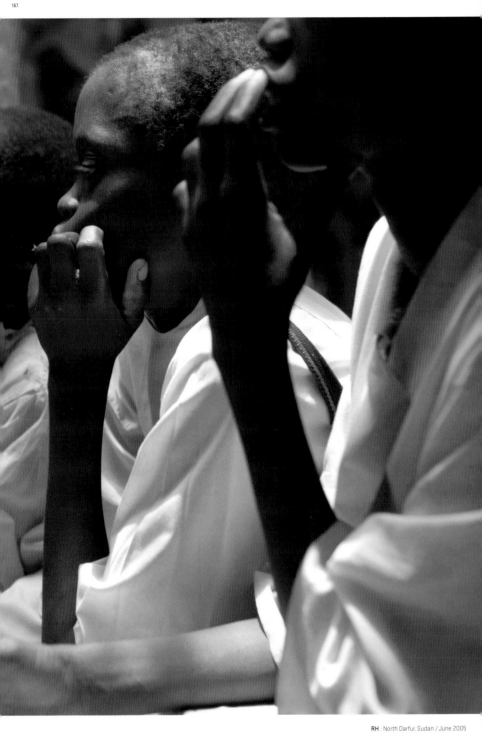

RH : North Darfur, Sudan / June 2005

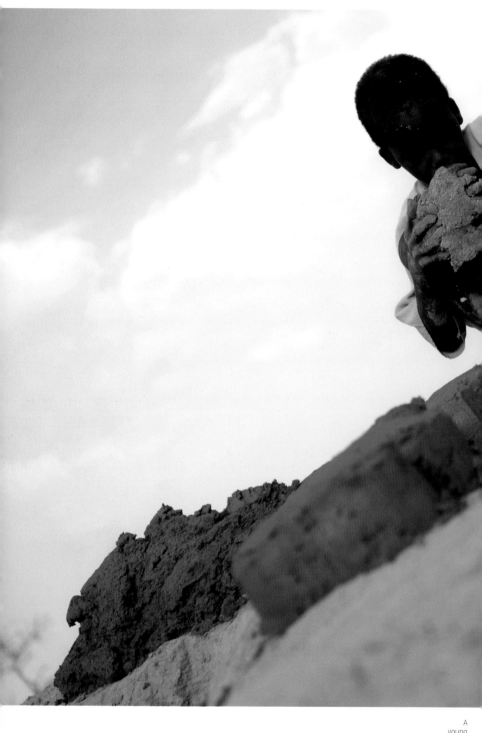

A young Darfuri refugee makes bricks at the Iridimi Camp.

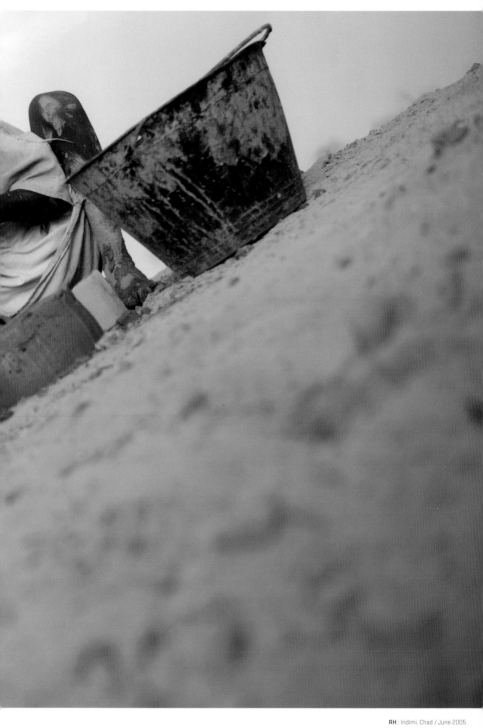

RH : Iridimi, Chad / June 2005

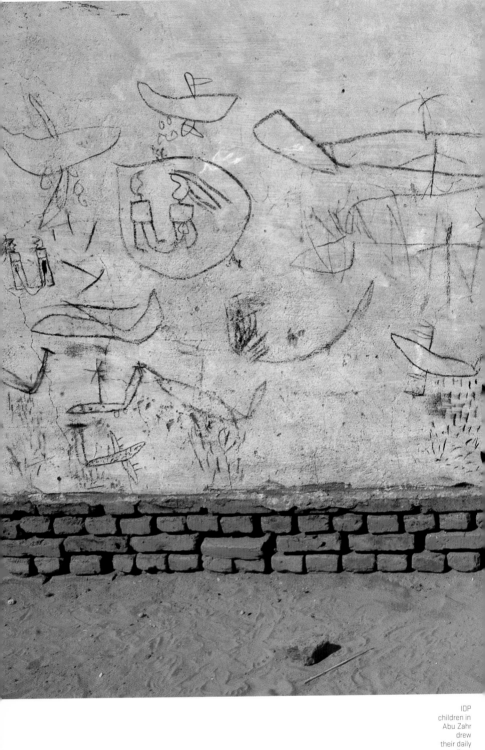

IDP children in Abu Zahr drew their daily lives on the wall of one of the school buildings: every day for three weeks in 2004, they saw World Food Programme (WFP) planes air dropping food near the school.

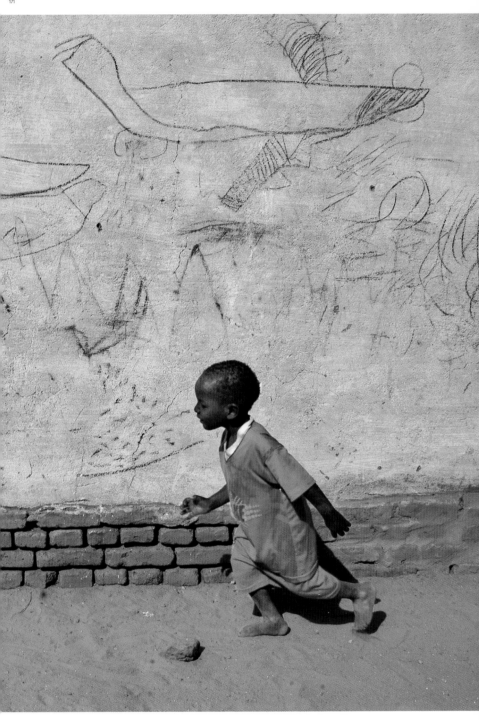

CAPTIONS FOR FOLLOWING PAGES

HC : Abu Zahr, West Darfur, Sudan / October 2004

LEFT TOP TO BOTTOM
MRS : Bahai, Chad / October 2004
Children in a refugee camp play with makeshift toys.
LA : North Darfur, Sudan / October 2005
Children play in the Zam Zam Camp outside of El Fasher.
MRS : Bahai, Chad / October 2004
After risking her life by leaving the camp, a young girl returns with
the wood she has gathered.

RIGHT TOP TO BOTTOM
LA : Chad / October 2004
A Sudanese boy walks through the Breidjing refugee camp.
MRS : Bahai, Chad / October 2004
Refugees expand a UNHCR tent from available scraps.
BS : Chad / December 2005
Two brothers in an IDP camp.

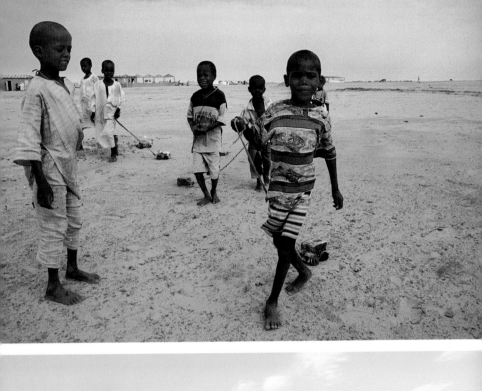

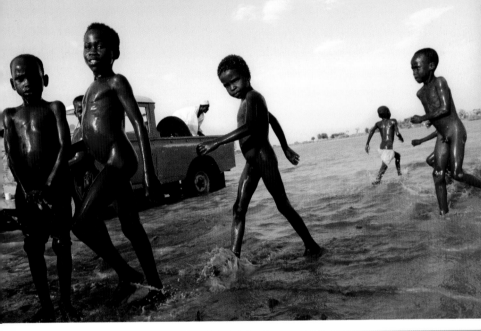

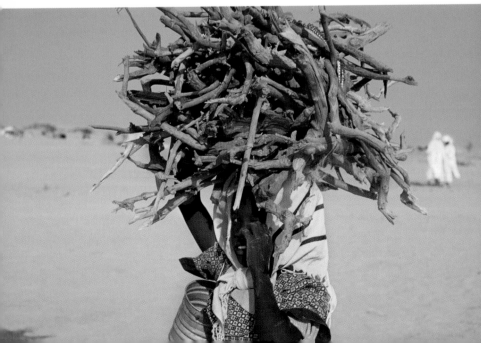

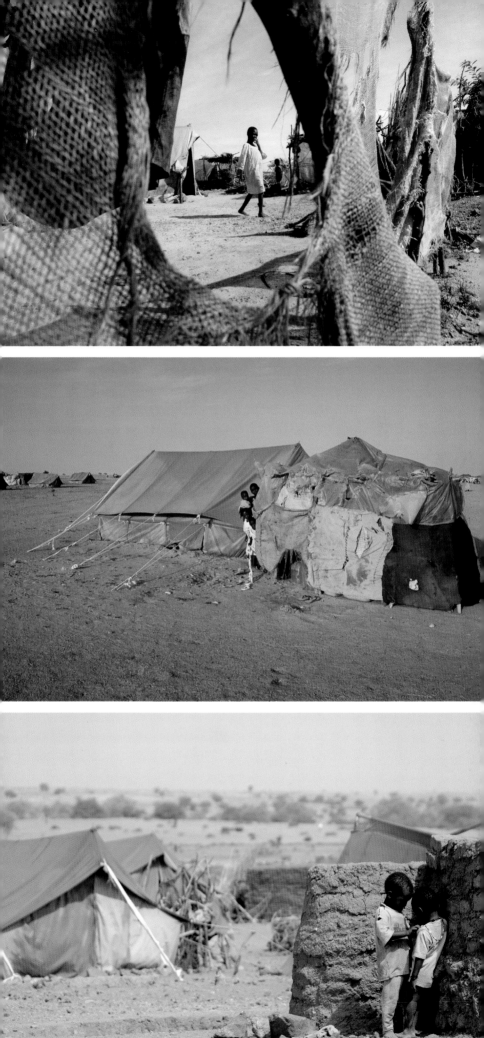

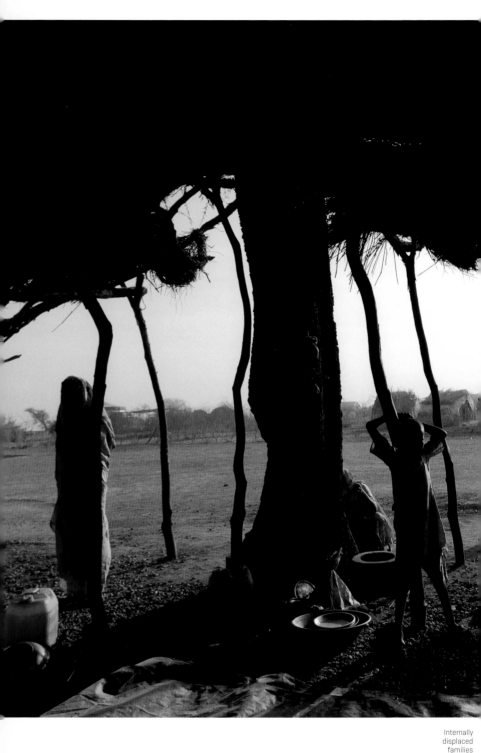

Internally
displaced
families
in
their
makeshift
home
awaiting
shelter
shortly
after
arriving
at
the
Hamadiya
Camp.

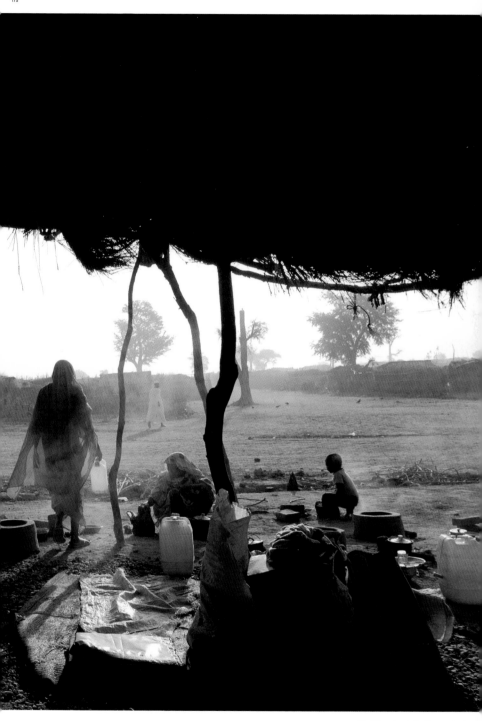

LA : Zallingi, West Darfur / February 2007

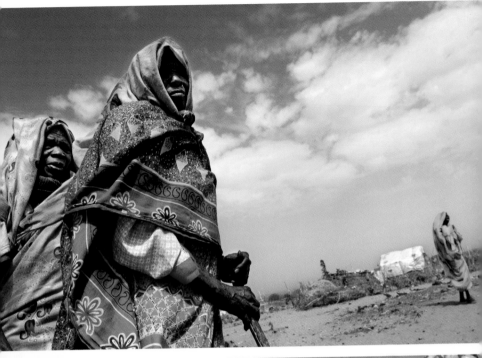

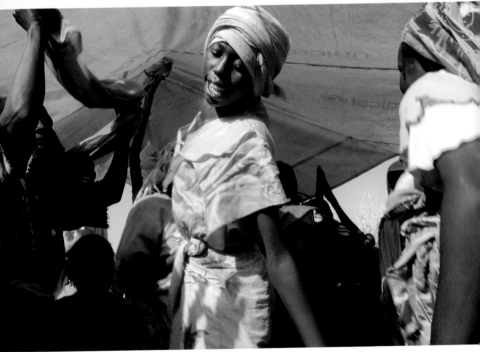

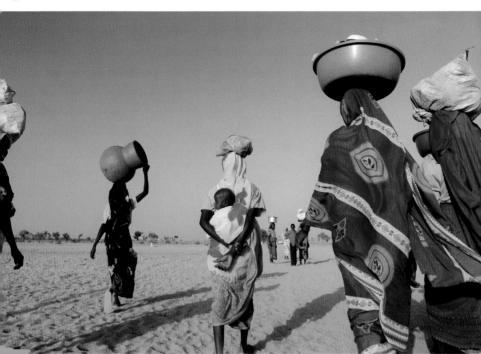

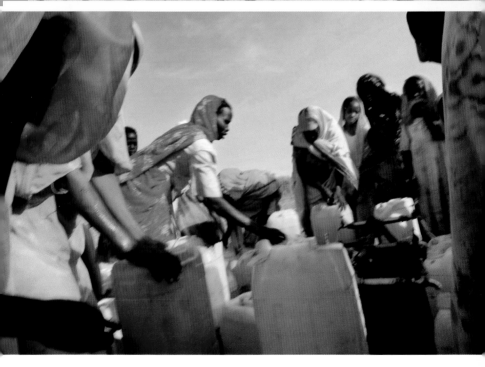

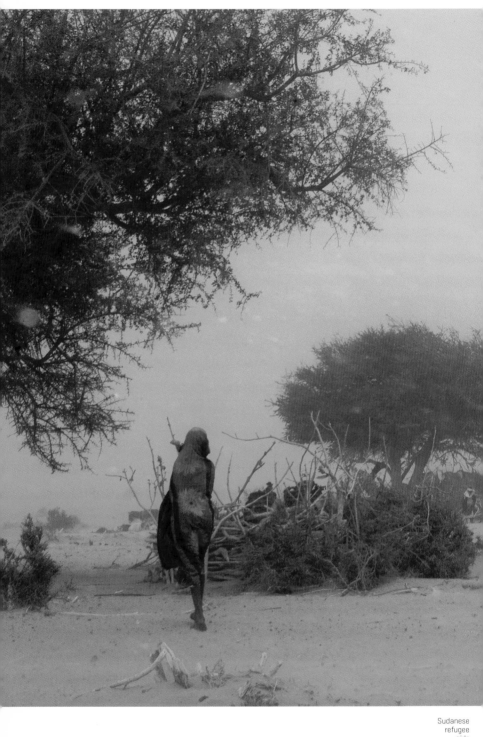

Sudanese refugee girls stand in the middle of a sandstorm near Tine after fleeing their village in Darfur with their families.

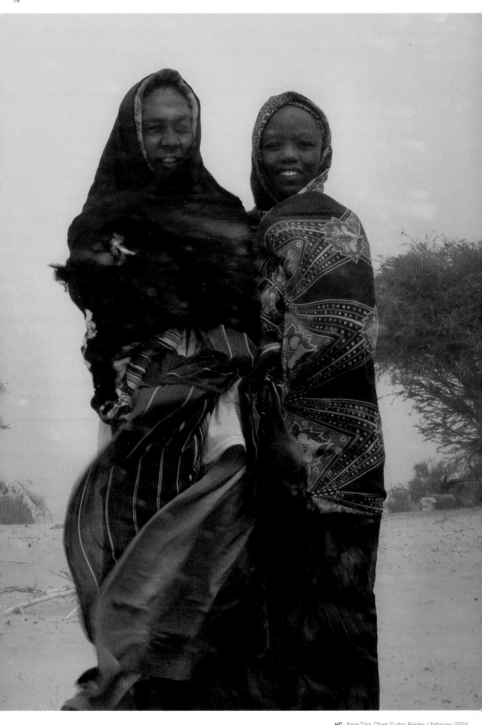

HC : Near Tine, Chad-Sudan Border / February 2004

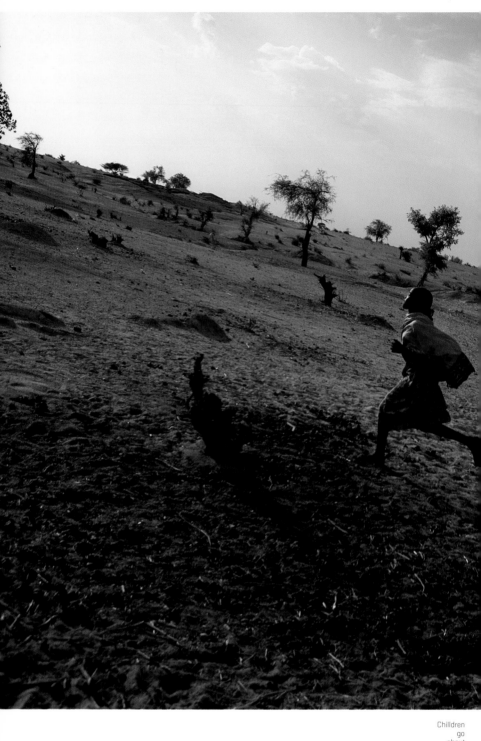

Chilldren
go
about
their
daily
life
at
an
IDP
camp.

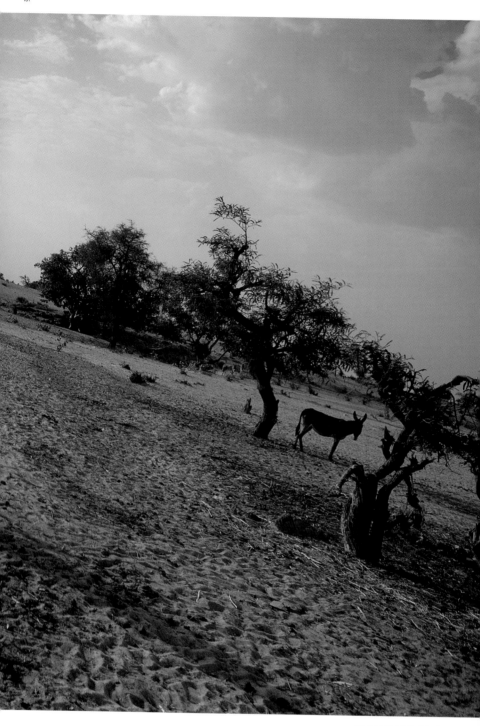

RH : Seliah, West Darfur, Sudan / June 2005

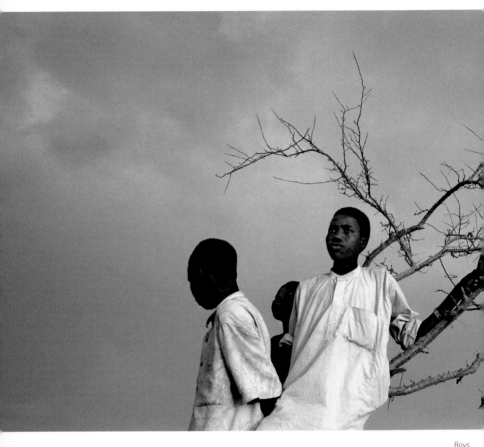

Boys
relax
at
the
end
of
a
long
day
in
Morni
camp.

CAPTIONS FOR FOLLOWING PAGES

RH : Morni, Darfur, Sudan / June 2005

LEFT TOP TO BOTTOM

MRS : Bahai, Chad / October 2004
Water arrives to the refugee camps in a water tank on a truck, taken
out from a well a few kilometers away.
LA : Darfur, Sudan / August 2004
Soldiers with the SLA eat breakfast at the Shingekaro base.
RH : Fina, Darfur, Sudan / June 2005
A boy watches as a WFP helicopter takes off from the isolated town
of Fina.

RIGHT TOP TO BOTTOM

RH : Seliah, West Darfur, Sudan / June 2005
A young boy cries in Seliah Camp.
MRS : Bahai, Chad / October 2004
Men unload flour at a food distribution center.
RH : Kass, Darfur, Sudan / June 2005
Young girls at a camp for IDPs.

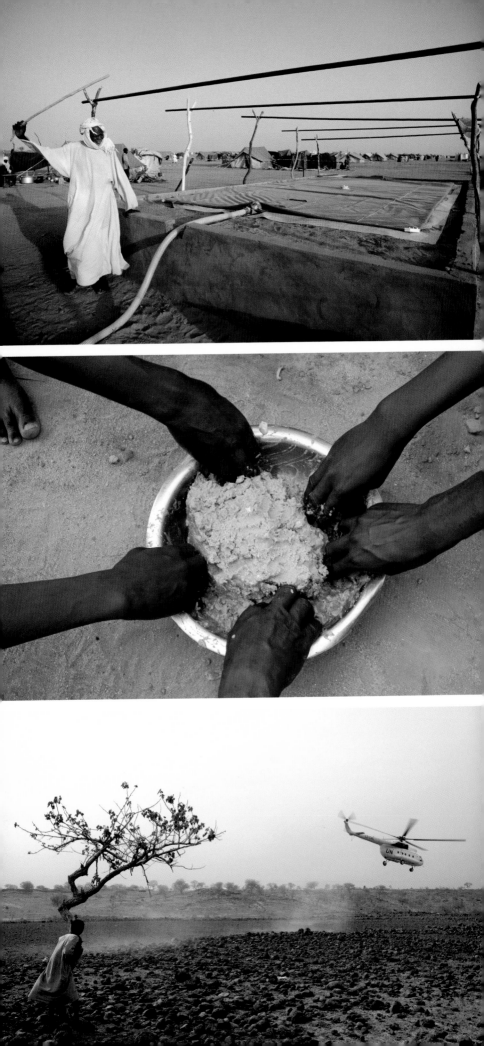

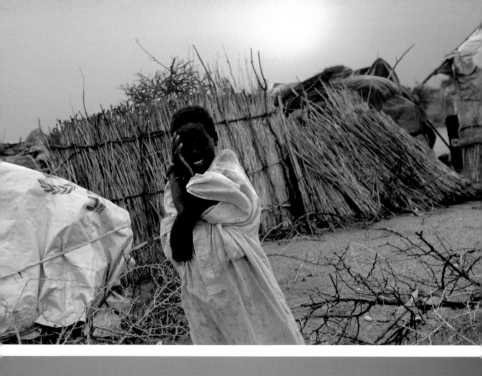

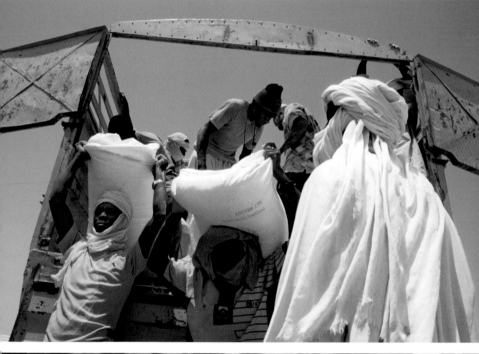

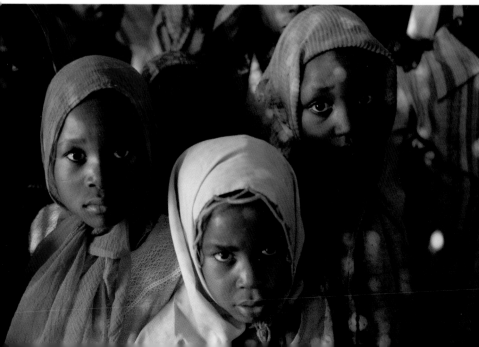

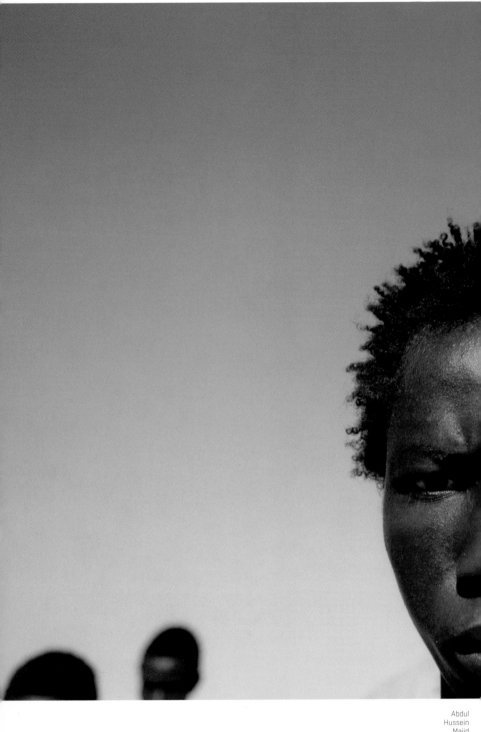

Abdul
Hussein
Majid
Quing,
age
16,
stands
at
attention
while
being
trained
with
other
new
recruits
for
the
SLA
in
Bahai,
Sudan.

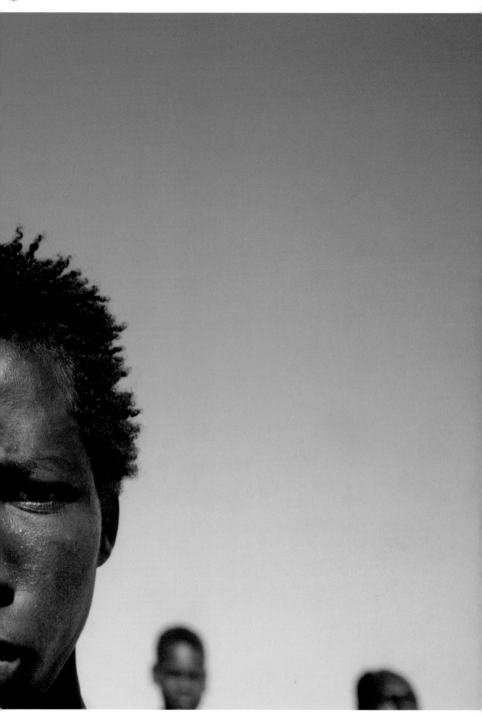

LA : Bahai, Chad / August 2004

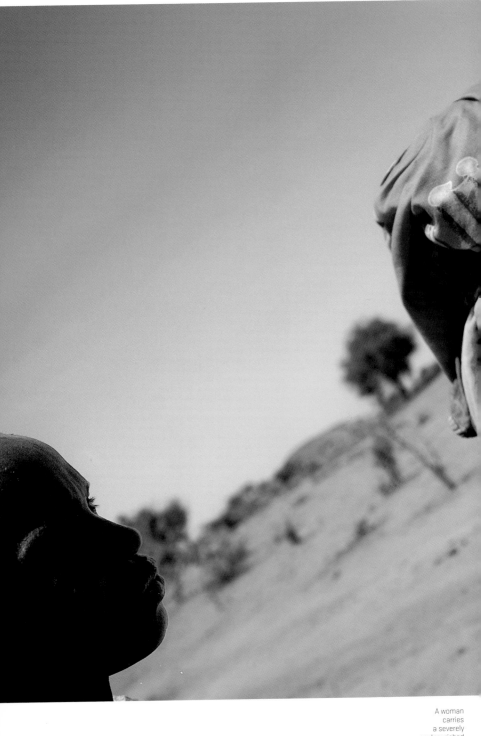

A woman
carries
a severely
malnourished
baby back
home
after visiting
a hospital, where
doctors
said they
were unable
to treat
the infant.
Subsequently,
UNICEF
staff took the
child to
a Concern
feeding center,
where the
child
was reported
to be
improving.

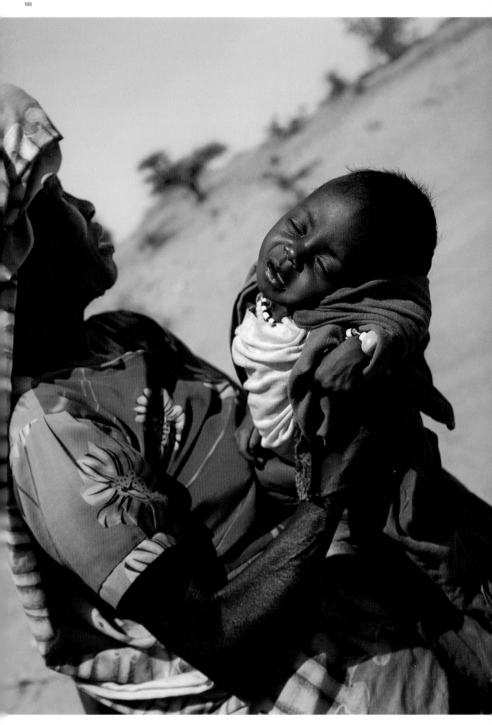

RH : West Darfur, Sudan / June 2005

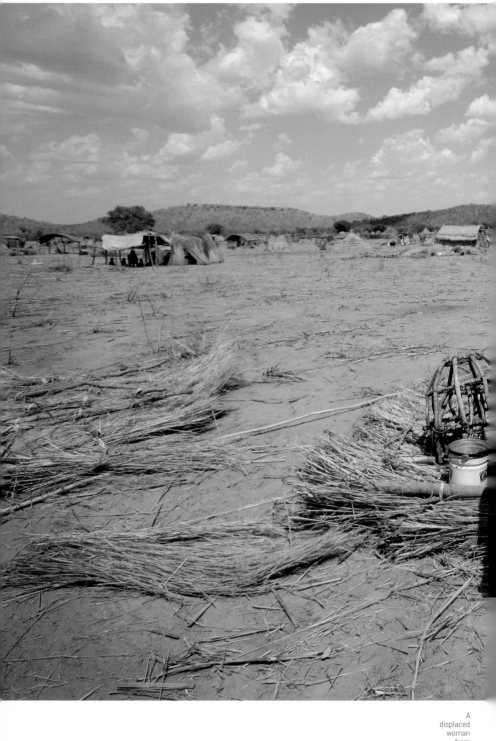

A displaced woman from Gouroukoun site arrives in a host village near Goz Beida where she will have better access to the limited water resources.

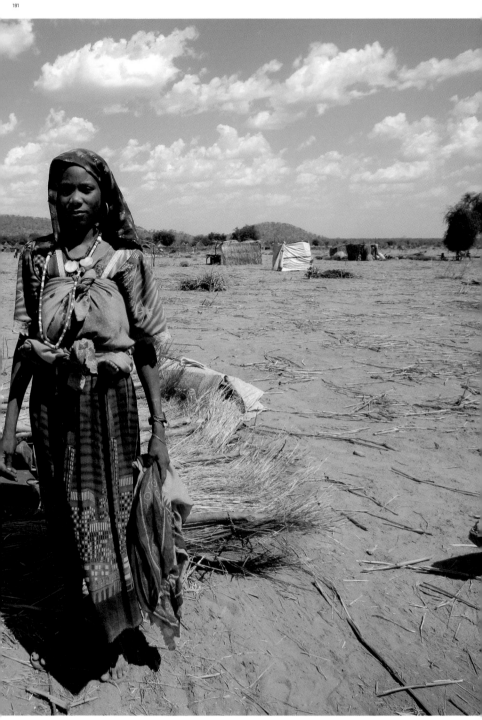

HC : Gouroukoun. Eastern Chad / June 2006

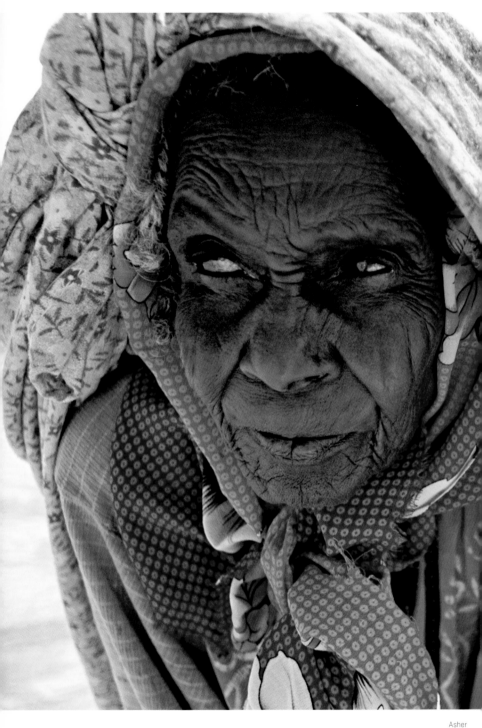

Asher walks for hours in search of food. She and her family fled their village when they heard government airplanes flying overhead; they feared more attacks.

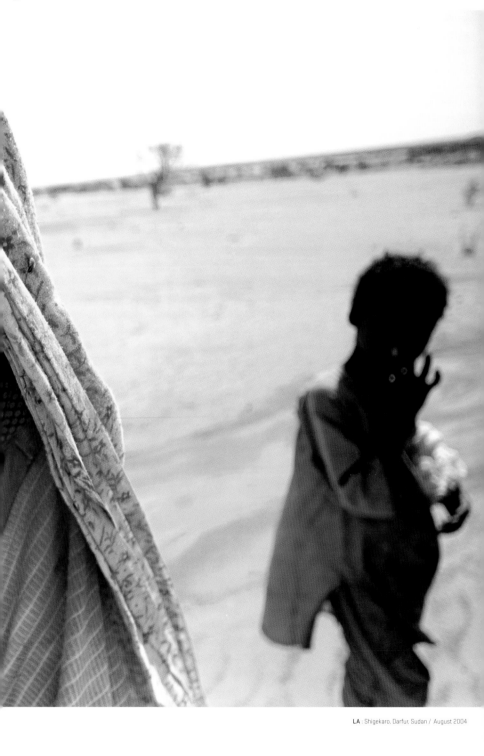

LA : Shigekaro, Darfur, Sudan / August 2004

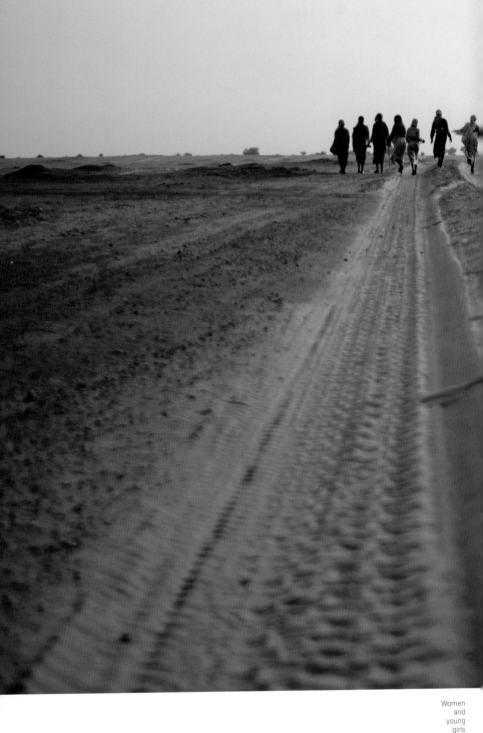

Women and young girls leave an IDP camp to gather firewood. For some, the work will take more than seven hours and lead them past government checkpoints, exposing them to attacks.

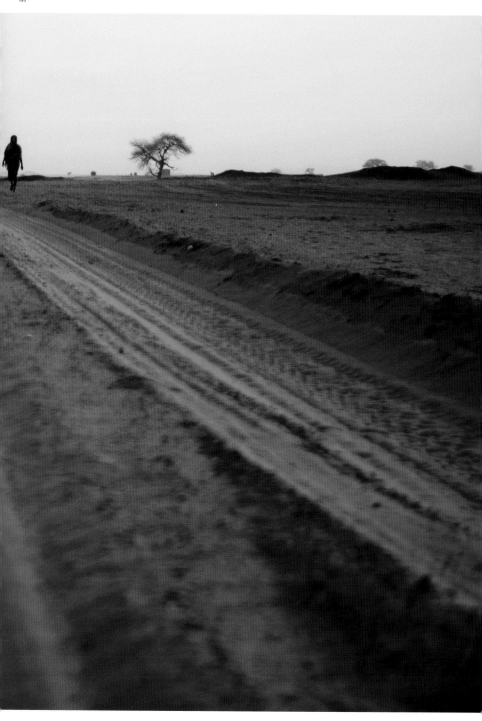

RH : Abu Shouk, North Darfur / June 2005

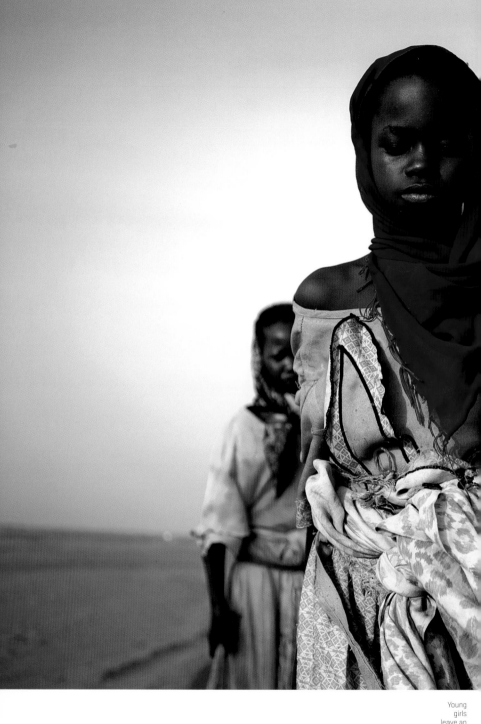

Young
girls
leave an
IDP
camp,
often for
a long
journey,
to
gather
firewood.
Girls
as
young
as eight
have
been
raped,
attacked, or
killed
trying
to
collect
wood.

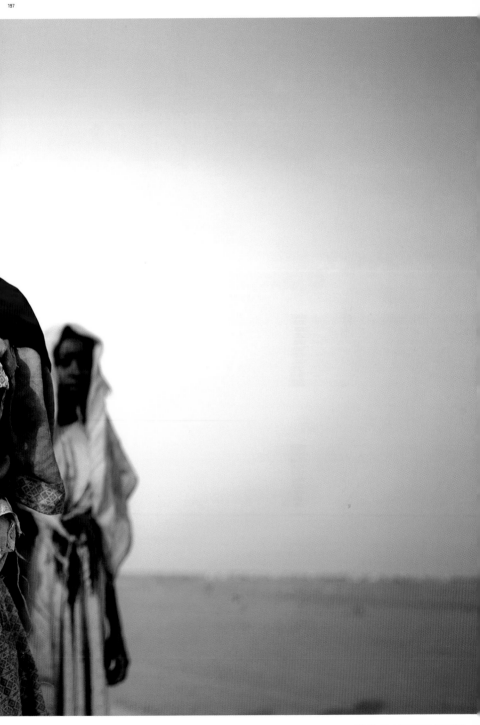

RH : Abu Shouk, North Darfur / June 2005

WRITE A LETTER
SAVE A LIFE

You
can help
the people of Darfur
by standing up
for their
political rights.

LIFE / WAR

Tear this piece
of paper out
and tell us
how you
would like to
help
the people of
Darfur.

There are
many
urgent needs
you can
write
about,
including:

An end to violence
against civilians in Darfur.

The provision of humanitarian aid.

The establishment of a stable peace
so that a safe and dignified
return of all displaced persons to their
homes can be achieved.

The implementation of justice
so that the perpetrators of this violence
are held accountable.

We will collect the letters
into a new book
and deliver
it to political representatives
so that they
can see how much you want
this crisis ended.

Your concerns will push them
to work for peace.

Please
send
your letters
to
Melcher
Media
124 W 13th Street
New York, NY
10011

A
portion of the
proceeds
from the sale
of this
book
will be used
to provide
a new school
for girls
in Darfur.

The
DARFUR/DARFUR
team is
greatful for the
chance
to contribute
to lives of
the brave people of
Darfur
who have
shared
their stories
with us.

A pictoral
essay
of this project
will be
posted at
www.darfurdarfur.org

African Union /
An organization established in July 2002 that consists of fifty-three African states. It aims to help promote democracy, human rights, and development across Africa.

Darfur /
A region of Western Sudan bordering Libya, Chad, and the Central African Republic.

Displacement camp /
Any temporary facility for displaced persons.

Hijab /
The traditional head and body dress worn by Muslim women, as mandated by the Koran.

IDP camp /
A camp run by relief agencies as a haven in which Internally Displaced Persons can obtain basic food, water, and healthcare services.

Internally Displaced Persons (IDPs) /
Individuals who have left their homes because of war, natural disaster, or persecution, but have not crossed any international borders.

Janjaweed /
A group of armed militiamen believed to be funded and supported by the Sudanese government.

Justice Equality Movement (JEM) /
An armed political group that gained power after the SLA and opposes the Sudanese government in Darfur. Its goals are supposedly similar to those of the SLA, and the two groups operate together. The JEM is believed to be close to the Popular Congress, an Islamist party that opposes the Sudanese government and is said to be led by Dr Hassan al-Turabi.

Koran /
Islam's sacred text, which Muslims believe to contain the revelations of God, as told to the prophet Muhammad.

Médecins Sans Frontières (Doctors Without Borders) /
A secular humanitarian-aid, non-government group that sends physicians and other health workers to war-torn regions and developing countries facing endemic disease.

Rebel /
A person who acts contrary to the constituted authority, control, rules, or tradition.

Refugee /
A person who is outside his or her country of origin due to a well-founded fear of being persecuted for reasons of race, religion, nationality, membership to a particular social group, or political

opinion. A refugee cannot or will not return without risking human rights abuses, and his or her government cannot or will not offer protection.

Refugee camp /
A temporary camp built by government or non-government organizations to provide food and medical aid to refugees.

Sudan Liberation Army (SLA) /
An armed group of loosely associated rebels who gained prominence in February of 2003 after it launched attacks against the Sudanese government. The SLA claims to have taken up arms because of the government's failure to protect people from human rights abuses in the Darfur region.

United Nations High Commission for Refugees (UNHCR) /
Established in 1950, the UNHCR helps protect and assist refugees and internally displaced persons and also aids in their resettlement.

Wadi /
A valley or dry riverbed that only carries water during the rainy season.

World Food Programme (WFP) /
An agency of the United Nations that distributes food to those who are unable to produce or obtain enough food for themselves and their families.

LYNSEY ADDARIO

Lynsey Addario is a photojournalist based in Istanbul, Turkey, where she works for publications such as **National Geographic, The New York Times,** and **The New York Times Magazine,** among others. With no professional training or studies, Addario began photographing in 1996 for the **Buenos Aires Herald** in Argentina. Since then, she has traveled the globe covering a wide range of subjects, including, but not limited to, the influence of capitalism on young Cubans, human rights and women's issues in South Asia, Afghanistan under Taliban rule, immigration in Mexico, and the wars in Afghanistan and Iraq. In August 2004 she began her coverage of the ongoing conflict in Darfur for the first time. Since then, she has traveled to Darfur and neighboring Chad several times, documenting internally displaced people and the rebel groups in Darfur. She was born in Norwalk, Connecticut.

MARK BRECKE

Mark Brecke is a filmmaker and documentary photographer whose work documents the stories of people victimized by war, ethnic conflict, and genocide. For more than ten years and across three continents, he has covered some of the most troubled regions of the world, including Cambodia, Rwanda, Kosovo, Sudan, the West Bank, and Iraq. In September 2004 Brecke started photographing the refugee camps of eastern Chad and traveled behind rebel lines in the Darfur region of Sudan with the Sudanese Liberation Army. For the past two years, he has traveled around the United States lecturing and presenting his Darfur photographs to more than one hundred different audiences. In 2006 the U.S. Senate selected ten of Mark's Darfur photographs to be hung in the Russell Rotunda of the U.S. Senate Building in Washington, D.C. In 2007 Brecke released his new film, **They Turned Our Desert Into Fire,** a documentary about the Darfur crisis. He lives in California.

HÉLÈNE CAUX

Hélène Caux has been combining photography and humanitarian-aid work for the past twelve years. Born in Amiens, France, she earned a master's degree in American history from the Sorbonne University and an advanced degree in journalism from Institut Pratique de Journalisme in Paris. Since then, she has covered women's issues in west Africa, the demilitarization process in Liberia, and life and war in Kosovo—to name just a few. Caux has been regularly documenting the humanitarian crisis and human rights abuses in Darfur and eastern Chad since the end of 2003. She spent 2004 at the Chad-Sudan border and in Darfur, and has returned to the region repeatedly in 2005, 2006, and 2007. Her exhibition Surviving Darfur was on display at the National Geographic Museum at Explorers Hall in Washington in 2005 and has been touring the United States ever since.

RON HAVIV

Ron Haviv has produced some of the most important images of conflict and humanitarian crises that have made headlines around the world since the end of the Cold War. Haviv is a cofounder of VII, whose work has been published by top magazines and exhibited in galleries and museums worldwide. With a special focus on exposing

human rights violations, Haviv has covered conflict and humanitarian crisis around the world. Most recently he has documented wars in Darfur and the DR Congo. His often-searing photographs have earned Haviv some of the highest accolades in photography, including awards from World Press Photo, Pictures of the Year, Overseas Press Club, and the Leica Medal of Excellence.

PAOLO PELLEGRIN

Paolo Pellegrin became a Magnum Photos nominee in 2001 and a full member in 2005. He is a contract photographer for Newsweek and has published five books. Pellegrin is the winner of many awards, among them eight World Press Photo, numerous POY Awards, a Leica Medal of Excellence, an Olivier Rebbot Award, the Hansel-Mieth Preis, and in 2007 the Robert Capa Gold Medal Award. In 2006 he was assigned the W. E. Smith Grant in Humanistic Photography. Pellegrin was born in Rome and currently lives in New York and Rome.

SAMANTHA POWER

Samantha Power is the Anna Lindh Professor of Practice of Global Leadership and Public Policy at Harvard's John F. Kennedy School of Government. Her book **A Problem from Hell: America and the Age of Genocide** was awarded the 2003 Pulitzer Prize for general nonfiction, the 2003 National Book Critics Circle Award for general nonfiction, and the Council on Foreign Relations' Arthur Ross Prize for the best book on U.S. foreign policy. Power's **New Yorker** article on the horrors in Darfur won the 2005 National Magazine Award for best reporting. Power was the founding executive director of the Carr Center for Human Rights Policy (1998-2002). From 1993 to 1996 she covered the wars in the former Yugoslavia as a reporter for **U.S. News and World Report, The Boston Globe,** and **The Economist.** Power is the editor, with Graham Allison, of **Realizing Human Rights: Moving from Inspiration to Impact.** A graduate of Yale University and Harvard Law School, she moved to the United States from Ireland at the age of nine. She spent 2005-06 working in the office of Senator Barack Obama and is currently writing a political biography of the UN's Sergio Vieira de Mello.

RYAN SPENCER REED

Ryan Spencer Reed's journey documenting critical social issues began in 2002 after he studied medicine in college. After moving to Nairobi, Kenya, he went to the Kakuma refugee camp in north-western Kenya—home to more than ninety thousand refugees from conflicts across east Africa, most of whom are Sudanese from the southern war. Focusing exclusively on Sudan since that time, Reed has entered Sudan a half-dozen times in both the south and in Darfur, in addition to covering the mass exodus of refugees to eastern Chad. Since 2004 he and his work have moved about the country to universities in the form of lectures and traveling exhibitions. While his exhibitions are becoming more virally distributed by the day, his documentation of Sudan continues. Reed was born in Ludington, Michigan. To see more of his work, visit www.ryanspencerreed.com.

MICHAL RONNEN SAFDIE

Michal Ronnen Safdie was educated in the fields of sociology and anthropology at the Hebrew University and Brandeis University. In 1983

she took up architectural photography in Cambridge, Massachusetts. In 1995 she resided in Jerusalem, embarking on a two-year project documenting life at the Western Wall. Since then she has pursued a dual path of interest: abstract photography and journalistic essays. Her series of anthropomorphic trees brought about a search for a different kind of print and led to her use of the Iris print. In 2002 Ronnen Safdie documented some of the pre-Gacaca trials in Rwanda, which attempted to resolve the imprisonment of one hundred thousand perpetrators of the 1994 genocide. In October 2004 she photographed refugees from Darfur in the camps on the border of Chad. These two bodies of work were featured in an exhibition at the Skirball Cultural Center in Los Angeles titled Rwanda: After / Darfur: Now. Ronnen Safdie was born in Jerusalem.

BRIAN STEIDLE

Brian Steidle graduated with a B.S. from Virginia Polytechnic Institute & State University in 1999 and received a commission in the U.S. Marine Corps as an infantry officer. He completed his service with the USMC at the end of 2003 as a Captain. In January 2004 he accepted a contract position with the Joint Military Commission in the Nuba Mountains of Sudan working on the North-South ceasefire, now peace treaty, working his way up from a Team Leader to the Senior Operations Officer. In September 2004 he was invited to serve as one of only three Americans in Darfur as an unarmed military observer and U.S. representative to the African Union. He resigned his position after six months, convinced that he could be more effective by bringing his photographs and the story of what he witnessed to the world. He is the co-author of his memoirs, **The Devil Came on Horseback: Bearing Witness to Genocide in Darfur,** and the subject of the award winning documentary by the same title.

LESLIE THOMAS

Leslie Thomas is an architect and curator. Ongoing projects include the DARFUR/DARFUR exhibit, which she began out of a desire to bring the individual faces of the humanitarian crisis in western Sudan to the world. Exhibiting at such venues as the Los Angeles Hammer, the Boston ICA, the Royal Ontario Museum, the Jewish Museum in Berlin, and FORMA in Milan the exhibit has brought its large scale projections to the streets of the world's major cultural centers. A founding principal with LARC Inc. and LARC Studio, a national architectural practiced based in Chicago, New York, and Los Angeles, she is a graduate of Columbia University and the Georgetown University School of Foreign Service. An Emmy award winning art director, she is committed to the use of art and design for public good.

In gratitude
The DARFUR/DARFUR project
has been marked by such generosity
of spirit from so many that it is literally
impossible to thank those who have given
selflessly of their time and energy—
writing a single name immediately incurs
the chance of omitting another one.
That said, there are a few
who have donated so much time,
good will, creative thoughts,
and financial commitments over the life
of the project that they must
be named here. To all of the others—
please accept my deepest gratitude
for working so hard to change the world.

From the beginning
and for every day in between,
Gretchen Steidle Wallace,

For believing in the book
and holding a steady course,
Lia Ronnen
and for bringing beauty and
clarity to the darkest images,
Giorgio Baravalle

For contributing your brilliant
work and endless hours,
Lynsey Addario
Mark Brecke
Hélène Caux
Ron Haviv
Paolo Pellegrin
Ryan Spencer Reed
Michal Ronnen Safdie
Brian Steidle

For doing the impossible
over and over and over again,
J. Matthew Jacob

For lending your voice,
Hamza El Din
Khalifa Ould Eide & Dimi Mint Abba
Brett Fuchs
Rasha
Abdel Gadir Salim

For helping us understand
what we are seeing,
David Bobrow
The Compound
Volume, Inc.

For being there in the beginning,
the middle, and the end,
Daniela Hrzic
Alexandra Kerr
Kevin Martin
Jane Sachs

For providing the links
to the rest of
the world when we were drifting,
Jill Barancik
Bich Ngoc Cao
Winter Miller
Lai Ling Jew

For providing support
in the beginning, when we were so new,
Elizabeth Pressler
Susan Rodriguez

For providing support when we were
less new, more tired, and most needed it,
Humanity United

For taking the call,
James Bewley
Bridget Conley-Zilkic
Colleen Connor
Carole Anne Meehan

For joining us in word and sound,
Jesse Brenner
Yo-Yo Ma
Mia Farrow
Samantha Power

For getting it done when it was too much,
Clio Chafee
Megan Lawler
Marvelle Manga
Kimberly Merlin

For believing,
Julia Thomas and Michael Bobrow
Barbara and David Thomas
Erica Bobrow
Steve, Sam, and Sarah Pressler

And most important,
for carrying the water,
Michael Hrzic
Greg Doench
Bruna Hrzic

DARFURDARFUR LIFE / WAR

Published
by

**MELCHER
MEDIA**

124 West 13th Street New York, NY 10011
www.melcher.com

Distributed in the U.S. by DK Publishing, Inc.
www.dk.com

Publisher
Charles Melcher

Associate Publisher
Bonnie Eldon

Editor in Chief
Duncan Bock

Senior Editor
and
Project Manager
Lia Ronnen

Assistant Editor
Lauren Nathan

Editorial Assistant
Daniel del Valle

Production Director
Kurt Andrews

Design
de.MO

ISBN : 978-1-59591-045-5
09 08 07 10 9 8 7 6 5 4 3 2 1

Printed in Singapore

CIP Publication Date is available on file at the Library of Congress.